THE HISTORY OF AFRICAN ART

THE HISTORY OF AFRICAN ART

—

SUZANNE PRESTON BLIER

—

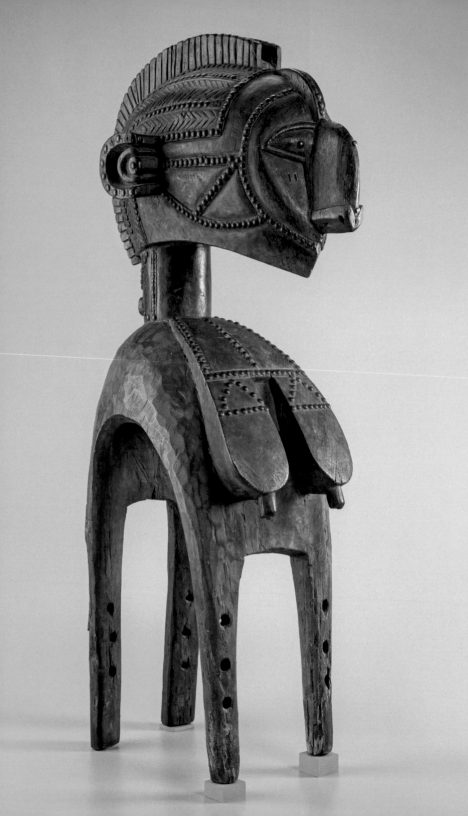

CONTENTS

INTRODUCTION

Africa is a vast, rich and diverse continent, with remarkable arts across its long history. These works and other visual culture evidence tell a deeply layered history for which often no written sources exist, helping us to better understand and re-envision the continent's historical roots and reshaping over time. This book is the first continent-wide overview of Africa's art history featuring a largely chronological narrative with period-specific engagements: Ancient, Medieval, Early Modern, Historic Legacy, Colonial and Contemporary Arts. Too often, still today, Africa is identified as a back water. African arts offer a very different narrative, despite sizable gaps in the material record in some geographic areas and periods. These works convey at once stunning beauty, distinction and complexity throughout the continent's longer history and how vital it is that Africa's extant material record be carefully preserved and expanded.

In bringing the full continent into perspective, it is important to emphasize how much Africa shares in

common – in its languages, cultural dynamics and even genetics. The continent's artistic roots are multi-faceted but also display complex overlays and engagements that offer yet another key layer to our understanding of African cultures and histories. While the Nile Valley (and Egypt more generally) has often been severed from the rest of the continent in art historical discussions, this is beginning to change. Egyptians long spoke an Afro-Asiatic language that belongs to the same linguistic family as languages spoken by Libyans, Nubians, Chad groups, many Kenyans and western Asians. Much of Central Africa and core parts of eastern Africa speak languages within the Bantu cluster deriving from the Nigeria–Cameroon borderlands. Population movements and genetic patterns suggest similar cross-currencies. In 10,000 BCE, Mauritanians and Egyptians shared similar DNA. Egyptian DNA includes 20% or more sub-Saharan African markers, alongside markers for Amazigh, Middle Eastern and Mediterranean people. Scholars see no real division between Egyptian and Nubian DNA. The largest western Asian indicators in Egypt are found in the Nile Delta, diminishing as one goes south, and Mediterranean elements arrive here relatively late. Nubians also have diverse backgrounds; their DNA is a mix of sub-Saharan African and western Eurasian components. African civilizations often went out of their way to draw on these connections in their arts.

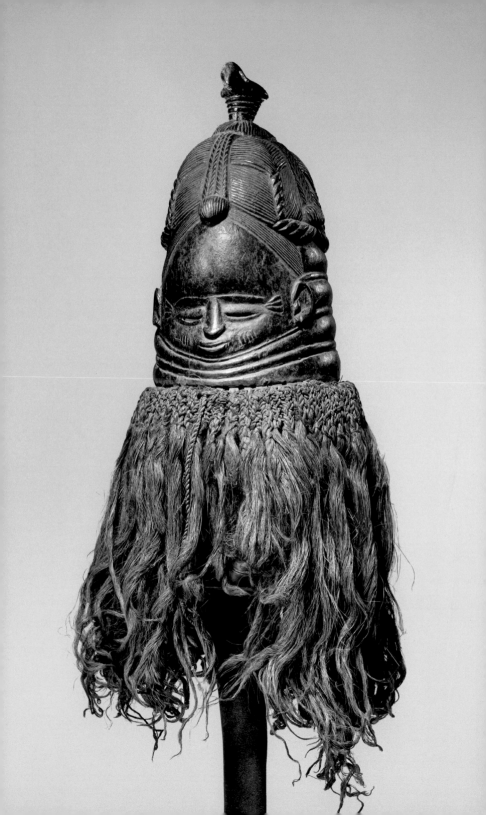

ENGAGING AFRICAN ART:
AN OVERVIEW

-

The night has ears

-

Masai proverb

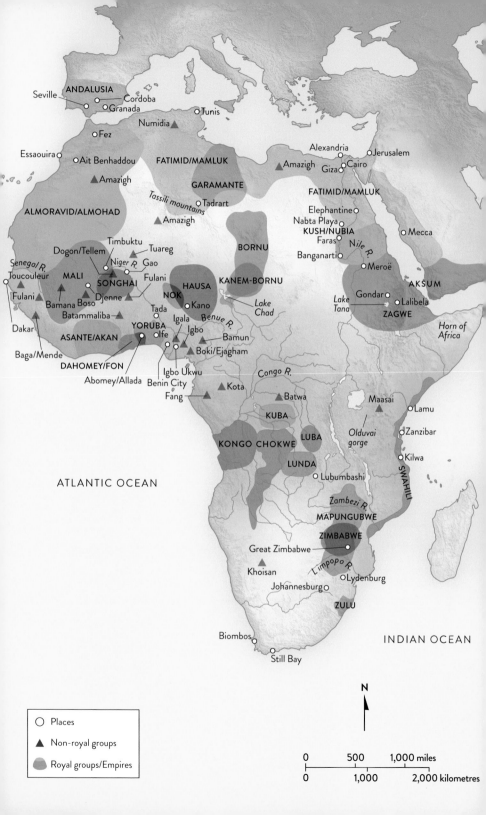

Seville
ANDALUSIA
Cordoba
Granada
Tunis
Numidia ▲

Fez

Essaouira ○

Ait Benhaddou ○
Amazigh ▲
FATIMID/MAMLUK
GARAMANTE
Tadrart ○
Alexandria
Amazigh ▲
Giza
Cairo
Jerusalem

ALMORAVID/ALMOHAD
Tassili mountains
Amazigh ▲
FATIMID/MAMLUK
Elephantine
Nabta Playa
Mecca
KUSH/NUBIA
Faras
Nile R.

BORNU
Banganarti
Meroë
AKSUM

Dogon/Tellem
Timbuktu
Tuareg
Senega/ R.
Niger R. Gao
Toucouleur ○
MALI
SONGHAI
Fulani
KANEM-BORNU
Lake Tana
Gondar
Lalibela
ZAGWE

Fulani
Bamana Boso
Djenne
HAUSA
NOK
Kano
Horn of Africa

Dakar
Batammaliba ▲
Tada
Igala
Igbo
Benue R.
Bamun
ASANTE/AKAN
YORUBA
Ilfe
Baga/Mende
DAHOMEY/FON
Igbo Ukwu
Benin City
Boki/Ejagham ▲
Abomey/Allada
Congo R.
Fang
Kota ▲
Batwa ▲
Maasai ▲
Lamu

Olfe
KUBA
Olduvai gorge
Zanzibar

KONGO
CHOKWE
LUBA
Kilwa

LUNDA
SWAHILI

Lubumbashi

ATLANTIC OCEAN
Zambezi R.
MAPUNGUBWE

ZIMBABWE
Great Zimbabwe
Khoisan ▲
Limpopo R.
Lydenburg
Johannesburg

ZULU

Biombos
INDIAN OCEAN

Still Bay

N

○ Places
▲ Non-royal groups
▨ Royal groups/Empires

0 500 1,000 miles
0 1,000 2,000 kilometres

Anonymous mapmaker
Chief Route of Explorers,
1883
Antique engraved map
Published in *The Universal
Geography* by Élisée
Reclus, London, 1878

**Maps such as these show
how important east–west
as well as north–south
trading networks were,
even if this map provides
only a partial view of
present and historical
locales. Missing here are
trade networks following
important river systems
in more heavily forested
West and Central African
areas.**

Map of Africa indicating
key locations, groups and
empires referenced in
the text.

**The origin and meaning
of the name 'Africa' are
debated, but it likely
references the Roman
term for North Africa's
Amazigh (Berber and
Libyan) culture, *Afri*
(Aourigha), or the
Latin word *aprica*,
meaning sunny.**

Trade played a critical role in African art history, often enhancing
and promoting creativity in cultures across the continent (opposite).
People generally followed longstanding continent-wide trade
networks (above). Sometimes cross-regional local arts, cultural
forms and trading languages emerged. These include, among others,
Mande and Hausa (West African savanna area), Kiswahili (the East
African coast) and Bantu (Central Africa – accompanying Bantu
iron and population dispersal). The Amazigh founded new trade
centres in North Africa and Andalusia during Islam's expansion.
When Europe turned to the gold standard in 1300 CE, African
centres became even more important since the richest gold fields
were south of Mali in today's Ghana and Guinea.

Africa's importance as a global trading network is seen in the
1375 Catalan map by Abraham and Jehuda Cresques (overleaf),
master cartographers and nautical instrument makers from Majorca.
This large map (only part shown here) included the then known
world – Europe, Africa, the Middle East and Asia – and main trade
routes connecting European centres with the best-known ones
outside the continent. Mansa Musa (also known as Musa I, Kankan
Musa), the Soninke (Mali) emperor shown on this map, remains the
wealthiest individual to have ever lived. His international fame grew

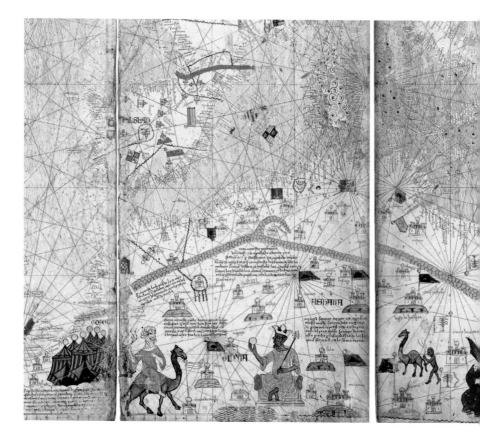

in 1325–6 CE on the annual Islamic pilgrimage, the Hajj, when
he donated and spent so much gold that he caused a global crash,
the first such large economic event.

The 1375 Catalan map also includes, on Mansa Musa's right,
a dark blue-attired ruler, identified as Organe, likely the Yoruba
emperor of Ife (Ile-Ife), whose earlier title was Ogane. Ife in this
era was an important glass-manufacturing and trading centre. Also
on the map, Christian Nubia's ruler is shown in pale green, east of
Organe. By 1375, Christian Nubia's power had diminished through
an administrative intervention by the Muslim Cairo Sultan, shown
on the map above the Nubian ruler, adjacent to the (bright crimson)
Red Sea. Turbans such as that depicted on the Organe were worn
by Coptic leaders and autochthonous Ife priests.

Christianity spread to Egypt in the 1st century CE and Coptic
Christianity remains one of the world's oldest and most important
Christian faiths. Mark the Evangelist is credited with founding

**Abraham and Jehuda
Cresques**
Catalan Atlas, 1375
(detail)
Parchment, 64.5 x 25 cm
(25½ x 9⅞ in.)
Bibliothèque nationale
de France, Paris

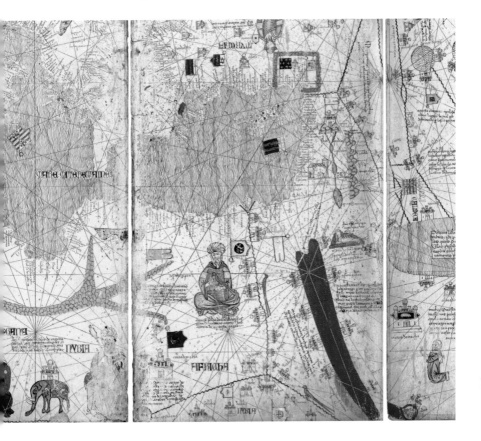

Here Mali's Emperor Mansa Musa holds a gold disc, indicating the empire's control of West African gold. Facing this king is a camel-riding Tuareg Amazigh, the group controlling the Sahara. To the right are kings of Organe (Ife), Nubia and Cairo. This map extends to the middle of West Africa's forest zone, although specific locales are only generally rendered.

a Christian patriarchy in Alexandria around 33 CE; by 300 CE, this Egyptian port city was a Christian heartland; from the 2nd century they advanced new ideas (labelled 'Gnostic' by other Christians) and followed celebrated local theologians both in Alexandria and in outside oasis monastic sites. Greeks called this area Aigyptoi, from Hut-ka-Ptah, referencing a deity's (Ptah's) temple in Memphis (now Cairo). In the late Roman era many Egyptians and North African Amazigh communities became Christian. After the Arab Islamic conquest of 641 CE, 'Copt' – originally the Greek term for Egyptian residents – designated specifically Egyptian Christians and their language. The Egyptian south (Nubia) lay outside Greco-Roman influence and did not initially become Christian, still worshipping Egyptian deities (in particular, Isis) into the 4th century. Eventually the Alexandrian and Coptic churches split. In the 6th century, Egypt saw active Christian missionizing in Nubia by Byzantine travellers bringing the Monophysite tradition. This resulted in a further split between

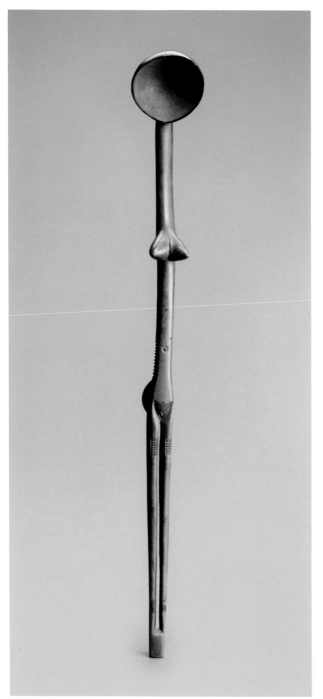

Zulu carver
Ngoni/Zulu spoon
South Africa,
19th–20th century
Wood, 54.5 x 7 x 7 cm
(21½ x 2⅞ x 2⅞ in.)
Pavillon des Sessions,
Musée du Louvre, Paris

**Zulu spoons marked
prestige and status
while scooping food
from a common bowl.
Guests brought their
own spoons; people
were served according
to their position and
family history, thus
reinforcing ancestral
and social connections
between living and past
family members. Richly
coloured Zulu beaded
garments and elaborate
jewelry similarly
delimited age, status
and identity.**

Khoisan peoples
Decorated ostrich egg
Botswana, 20th century
Shell, diameter
15 x 11.9 cm (6 x 4¾ in.)
Lam Museum of
Anthropology, Wake
Forest University,
Winston-Salem

**This beautiful work had
a practical function, as a
water container. African
terms for art vary, but are
often similar to Western
terms, evoking ideas of
'skill'. In certain respects,
all art works share
aesthetic and functional
values. Objects known
for everyday use, such as
this one, are both visually
appealing and functional.**

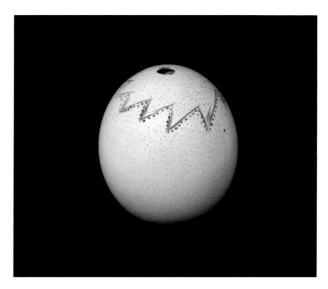

Alexandrian and Coptic churches. Here and elsewhere local
populations such as the Amazigh helped shape these new religions
through their beliefs, cultural practices and arts.

In some areas of Africa, groups moved around regularly, as
evidenced in the arts of the Zulu (South Africa), Turkana and Masai
(East Africa), and Fulani and Tuareg (West Africa). Early and later
fishermen and hunter-gatherer populations were among these
groups. Herders regularly migrated for pasturage. Starting around
1 CE, the Zulu became cattle herders. Women played a vital role
as builders of homes, preparers of food and mothers. This wooden
Zulu anthropomorphic spoon shows a richly stylized yet pared-
down aesthetic (opposite). Portraying a woman, this sculpture
incorporates a wonderful circular play (face, breasts, buttocks)
and subtle attenuations (neck, torso, legs) plus contrasting
elements – concave (face) and convex (breasts, buttocks).

Mobile populations also include some of Africa's earliest
populations – the Khoisan ('bushmen') of South Africa and
Mbuti, Baka and related ('Pygmy') populations of Central Africa.
The Khoisan have long created handsome decorated ostrich egg
water containers (above), some of which, as here, integrate patterns
from nature such as the path of a worm or snake. The Mbuti and
Baka peoples ('Pygmies') today living in Congo forests create
complex polyphonous music. Mbuti and related groups have long
fashioned painted raffia textiles (overleaf) from bark fibres and
used them as wearable art.

These early indigenous groups hold special ritual status as autochthonous residents with deep natural and spiritual world knowledge

Mbuti ('Pygmy') peoples
Bark cloth
Democratic Republic of
Congo, late 20th century
Plant fibres and pigment,
80.7 x 48.3 cm
(31¾ x 19 in.)
Minneapolis Institute
of Art

The bold patterning reflects African art's broader interests in dynamic design. Mbuti raffia cloth designs generally convey forest landscapes and fauna, suggesting symbolic maps. These visualizations often reflect a bird's-eye perspective, showing vines and upper tree limbs used to collect birds' eggs, honey and fresh leaves.

We are fortunate to know the names of a few historical African artists, for example, Ngongo ya Chintu (The Buli Master), from the central African Luba kingdom (opposite), who worked in the town of Buli in the 19th century. Among the Luba, rulers' thrones held special importance as symbols of political and religious legitimacy. His work is distinguished by emotional intensity, long faces and downcast eyes. Luba rank and title are defined by seating, with those of lower rank sitting on mats and animal pelts, and high-status individuals sitting on carved wooden thrones. Investiture rites take place on such thrones, in which the ruler's spirit is embodied. Luba thrones also evoke the legacy of Luba's 1585 founder, Mbidi Kiluwe, a famous hunter, whose most important possession, his bow, received a special bow stand as a symbol of his authority. Important art patrons are also known, such as the famous medieval Ife Yoruba king Obalufon II, who ruled this massive city-state-based polity (in today's Nigeria and parts of Benin and Togo) in c.1300.

Complex shrine and temple ensembles of art are important across the continent. In 1668, when Dutchman Olfert Dapper published a description of Benin City (Nigeria), he compared it favourably with

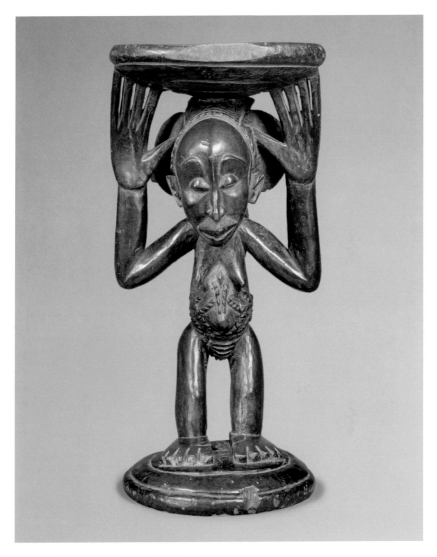

The Buli Master, possibly Ngongo ya Chintu (c.1810–1870)
Luba Chief's (Lupona) throne
Democratic Republic of Congo, 19th century
Wood and metal studs, 61 x 27.9 x 27.9 cm (24 x 11 x 11 in.)
Metropolitan Museum of Art, New York

Luba thrones were often covered in a white cloth and imbued with powers of the ancestral and living ruler. The Luba, like the Asante and Kongo, are a matrilineal group, tracing rulership through women (the king's mother's lineage). The woman on this throne references this female ancestry.

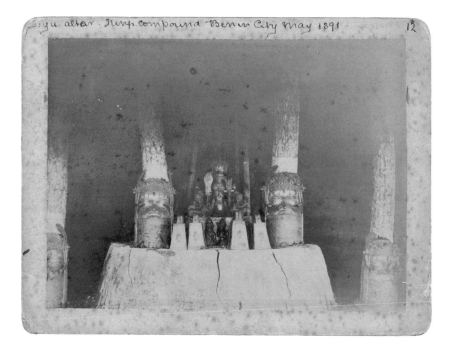

Iyu altar. King compound Benin City May 1891 12

great European cities such as Haarlem. Dapper's engraving includes the turret-decorated palace structure, one of which contained the main royal altars (above). As European missionizing and wars for slaves unfolded, praise of Africans changed to derogation, suggesting Africans lacked civilization and were less than human to justify these actions. Even while surviving this deadly international enslavement, Africans continued creating extraordinary arts.

In the 20th century, European and American societies embraced African visual arts (Picasso, Matisse) and music (jazz, blues)

A 16th-century Benin bronze altar sculpture from Nigeria (opposite) reflects how global religions likely were framed within and engaged Africa. This sculpture wears a square cross with equal-length, outward-flaring arms, recalling Coptic Nubian and Maltese crosses, the latter worn by medieval European religious orders such as the Knights of St John. His lace chasuble recalls late 15th-century Venetian examples. His cap suggests a rimmed priestly skull hat. Benin symbolic elements include a raised thumb (chieftaincy symbol), a blacksmith hammer (only the handle is preserved) and a

Benin artist
Royal altar with royal memorial heads (*uhunmwun elao*) and other works
Benin Kingdom, Nigeria
Photograph by trader Cyril Punch, 1891
Published in H. Ling Roth's *Great Benin; Its Customs, Art And Horrors*, Halifax, England, 1903

Striking bronze heads and other works were displayed on royal altars and address socio-cultural, political and religious ideas about rulership and power, especially the head as the centre of experience, leadership, good fortune and success in life. Bells called the gods to related ceremonies. This photograph is from the British-colonial expedition to Benin.

Benin bronze casting guild (Igun Eronmwon) member
Cross-wearing figure
Benin Kingdom, Nigeria, 16th century
Bronze,
56.5 x 23.5 x 22.2 cm (22¼ x 9¼ x 8¾ in.)
Barnes Foundation, Philadelphia

Scholars today identify the figure and cross with Benin's creator god, Osanobua, or Ewua court officials who woke the king each morning. Important earlier sources identified this as the messenger of Ife's Ogane (ruler), Ife's king once sanctified Benin rulers within their diplomatic and trading network. Because this sculpture and many other Benin palace arts were taken in the 1897 colonial drive, additional object information is lost.

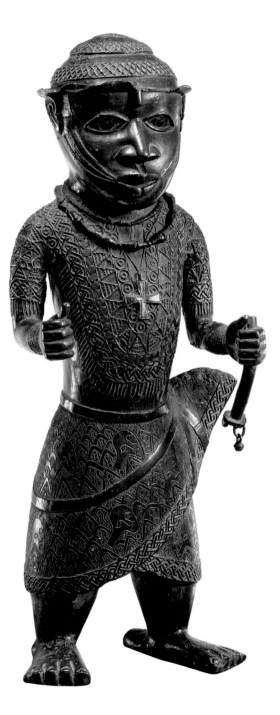

cloth wrapper with incised European heads, river leaves and mudfish. Benin shrine sculptures (such as page 19) also speak to area and global histories. In the 17th century, earlier likely Nile Valley-derived Christian communities were still present in the Bornu and Lake Chad area, and their influence had already reached the Niger–Benue confluence when Benin gained control over the region.

This work's unusual diagonal Yagba-Nupe facial marks reflect Niger–Benue confluence contact, the area with links for both Ife's and Benin's 2nd dynasties to the military leader Oranmiyan. Just as Islam was shaped by and helped to shape African art, politics and religious beliefs, so did Christianity. Whatever this work's identity today, it reveals Benin's (and West Africa's) connection to the larger pre-colonial Christian history of expansion. Following the conversion of Nubian rulers in 500–600 CE, Christianity flourished along the Nile through the later Medieval era, spreading west to Lake Chad and beyond. In Benin, after 1480, Portuguese ships following earlier efforts by Henry the Navigator (1394–1460 CE), leader of the Order of Christ, brought new missionary activity.

Cross-regional, cross-temporal artistic symbolic forms are important in Africa. One example is a bronze aegis (shield)-form sculpture (c.1340–1400 – opposite) associated with two great dynastic powers – Yoruba and Benin (in Nigeria). Created for a Benin patron, likely by a Yoruba artist, working perhaps within an area Ogboni workshop (an important medieval and later Yoruba bronze casters group), this work may address royal investiture or annual ceremonies that revitalize the king. This ruler wears distinctive Ife 1st-dynasty vertical facial lines (or a veiled crown) and a ram's head hip pendant. Two smaller priests grasp and support his arms while nature's potency re-empowers the king, state and population. We see in this bronze plaque noteworthy symbolic complexity including sirens (mermen) and fish-legged imagery (mudfish extending from the feet of the king) that appear to have travelled long distances in space and time, given that one of the earliest examples of this kind is seen centuries prior in Egypt.

We can see the ongoing importance of inner African contact and trade in certain jewelry and other forms small enough to travel. The Nubian gold shield (aegis) ring from Meroë (page 22), featuring the ram god Amun, shares complements with the early ram-headed Nile inundation deity Khnum. Amun, the god of dynastic leaders, referenced rulership longevity. Art works like these likely made their way from the Nile Valley to the Niger–Benue confluence area (most likely along the east–west trade route) during the c.1100–1300 period of serious drought and Islamic advance which

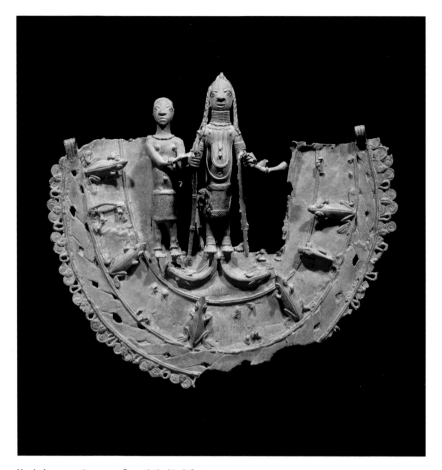

**Yoruba bronze casting
guild member
(Ogboni workshop)**
Yoruba/Benin aegis
(shield) plaque showing
king with two priests
Nigeria, 14th century
Bronze, height 39 cm
(15⅜ in.)
Benin City National
Museum

**Beneath the king's feet
are two outward-curving
mudfish (lungfish) –
beings that aestivate
and 'return' to life
with seasonal rainfall.
These recall siren
imagery popular in the
circum-Mediterranean
and African world from
antiquity to the present.
Frogs also evoke ideas
of transformation.**

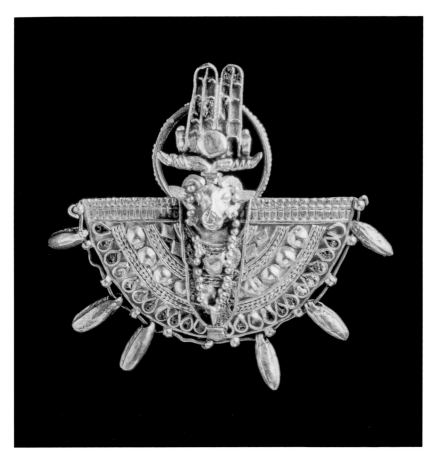

Nubian jeweller
Meroë Nubia gold
shield ring with head
of the god Amun
Sudan, c.10 BCE
Gold with glass paste,
4.5 x 3.6 x 2 cm
(1⅞ x 1½ x ⅞ in.)
Egyptian Museum and
Papyrus Collection, Berlin

This aegis (a miniaturized
broad collar necklace)
ring displays Amun's ram
head with prominent
inward-curving horns.
It is from the tomb and
treasury of the Meroitic
queen Amanishakheto
(Meroitic Amani,
c.10 BCE – 1 CE). This
queen is often shown
with the war goddess.

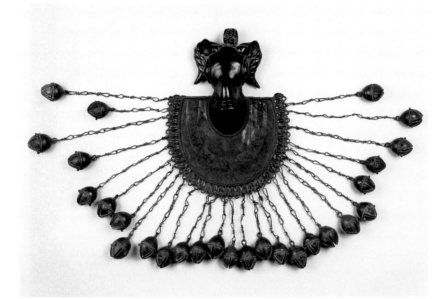

Yoruba bronze caster
Yoruba ram's head aegis
(shield) pendant
Apapa Hoard near
Lagos, Nigeria,
14th century
Bronze,
39.2 x 68.5 x 6.1 cm
(15½ x 27 x 2½ in.)
British Museum, London

**The aegis form of this
work and its prominent
ram's head motif suggest
key parallels with Nubian
forms, some of which
were carried or traded
westward to the Niger–
Benue river areas in the
Middle Ages.**

transformed the Christian-Nubian political Nile area. Refugees likely travelled with family relics, while other items were sold to traders who carried them more broadly.

In the broader lower Niger River area, among the Yoruba (Ife, Owo) and Benin kingdoms, a tradition of related aegis and other forms featuring ram heads on similar shield-like shapes, often cast from expensive copper alloys, bear complementary iconographic elements including dangles (above). In Yoruba contexts, the ram-head portrayals evoke similar ideas of dynastic continuity and rain control, the latter through the god Shango, deity of lightning and thunder. Sometimes these rams emit thunder axes. Similarly, in the elite medieval Nigerian Igbo Ukwu grave site, glass beads and other materials reveal not only connections with Yoruba culture at Ife to the north, but also with the Nile Valley (Egypt, Nubia), and traditions further east to India.

Another set of complementary examples addresses visual exchange in especially insightful ways. In the Nubian medieval site of Banganarti is a remarkable 13th-century wall painting of a Christian priest-ruler (overleaf) wearing attire that harkens back to Pharaonic Egyptian ideas, including an animal horn and feather-decorated crown. In this now remote southern Nile context, the imagery expresses ideas of earlier political power even in Christian contexts. Compare this image to a c.1340 CE richly attired, nearly

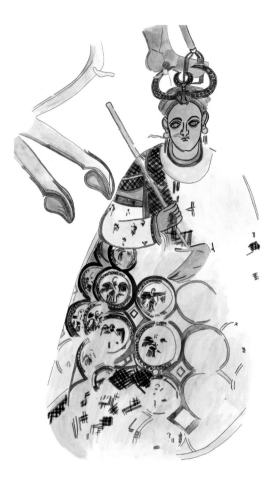

Coptic mural painter
Reproduction of a mural painting from Banganarti Sudan, 13th century Original in the Sudan National Museum, Khartoum

The robe, which incorporates a sweep of encircled winged forms (perhaps angels) shares complements with the Byzantine Mediterranean world and traditions, including the coronation robe of the Holy Roman Emperor c.1300, with similar looped-winged birds, although in this case referencing the eagle.

Lower Niger Ogboni bronze casting group
Tada Ruler-Priest Figure Yoruba, Nigeria, mid-14th century Bronze, height 115 cm (45⅜ in.) Nigerian National Museum, Lagos

life-size bronze priest-ruler figure (opposite) from the Niger River port town of Tada. The sculpture is sometimes identified as the Gara image, a name referencing a site near the Niger–Benue confluence area's Igala capital, Idah.

This strikingly detailed art work was likely created by a medieval Lower Niger Yoruba Ogboni casting group whose fine large-scale sculptures are distinguished by their large pupil-less eyes, often elaborated attire and complex gestures. The figure's robe, jewelry and crown are unique in local West or Central African traditional art forms, owing their roots instead to the Coptic (Byzantine) world and its Nile Valley Christian complements – traditions practised at Nubian centres such as Faras, Old Dongola and Banganarti. Like some medieval and earlier Nile Valley works, the Tada priest-ruler also wears a headdress of two horns (extending down the back)

On the Tada priest-ruler's chest is a triangular pendant decorated with a ram's head and birds, its imagery complementing Nubian forms that likely harken back to the ram god Khnum/Amun, revitalized in Christian Nubian contexts for royals. This ram imagery also complements Shango. This Tada shrine was associated with ceremonies around success in fishing and trade.

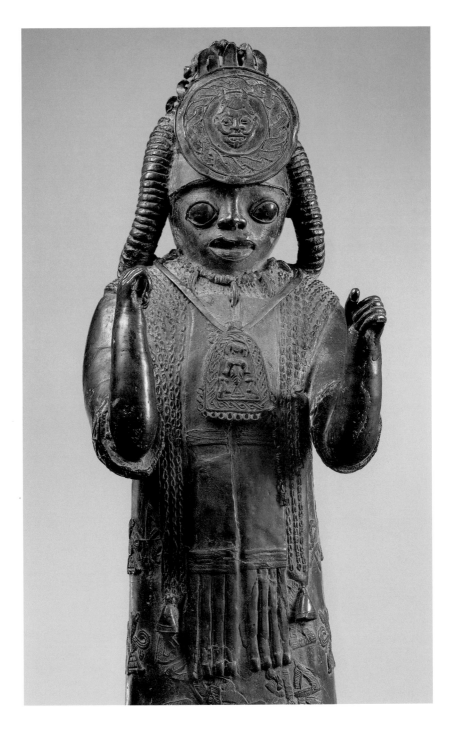

and feathers. Similar to the Banganarti wall painting priest-ruler, this Tada sculpture's gown includes looping wing figures, along with equal-armed crosses characteristic of Coptic and other eastern Christian traditions. The Tada priest-ruler's crown displays front and back circular diadems within an interlace surround recalling Byzantine and Coptic textile forms. This diadem displays a face with an extended tongue and snakes emerging from the nostrils and horns (recalling an ancient Greco-Roman Gorgon or Pharaonic Bes figure). During the Medieval era, Greco-Roman Gorgons were prominent in the eastern Byzantine world and forms bearing this imagery seem to have reached Nigeria through trade. A key Gorgon image source is the Cenacle (Room of the Last Supper), a Jerusalem pilgrimage site where a stone Gorgon head appears on an interior column capital. Among other works in the same Tada shrine site are a cast bronze baby elephant and two bronze ostriches (animals all associated with long-distance trade).

In some cases, early art forms (such as head rests) are so broad-based that they suggest deeper and older cross-continental connections, likely from very early periods in African history.

Egyptian ivory carver
Head rest
Deir el-Bersha,
Egypt, c.2000 BCE
Ivory, 15.5 x 18.4 x 6.7 cm
(6⅛ x 7¼ x 2¾ in.)
British Museum, London

Often no taller than three to four inches, such forms allowed a person to rest their head and upper neck in the cradle without negatively impacting their elaborate coiffure at night. Because such works are often passed down within the family, they carry the spirit-linked power of the ancestral line, providing added religious support and power to living family members.

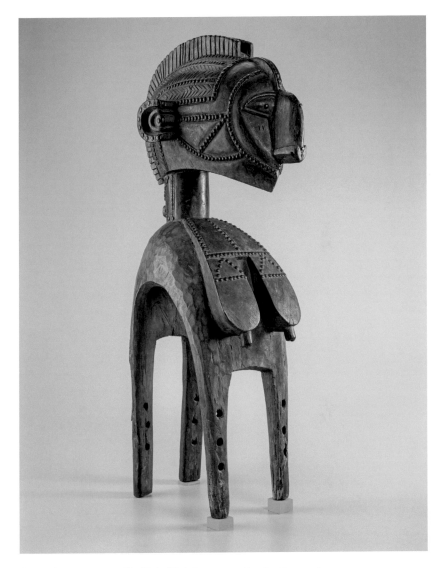

Baga wood carver
Baga D'mba mask
headdress
Guinea, late 19th–
20th century
Wood and brass,
132 x 39 x 61.5 cm
(52 x 15⅜ x 24¼ in.)
Yale University Art
Gallery, New Haven

The D'mba (Nimba)
mask is balanced on
the wearer's head; the
extensions on the front
and back are held to
keep it steady. The
wearer peers through
eye holes positioned
between the breasts.
At times, the mask is

positioned on the ground,
when participating in
harvest ceremonies and
marriages. Linear surface
patterns reference
agricultural rows that,
like the coiffure, recall
the Baga peoples'
connections with Mande
cultures further north.

One such curve-topped ivory head rest (page 26) is reminiscent of works we see in wood from East and Central Africa to West Africa today. Tracing art influences across trade routes allows us to discern how contact impacts art form and meaning. Cowries from the Indian Ocean reached the middle of West Africa in the Medieval era, serving simultaneously as currency and decorative objects. Both the Nile and Niger–Benue river areas were part of the Asian Silk Road trade network. Silkworm harvesting and textile manufacturing remained important in the Yoruba Ife area and elsewhere.

In pre-colonial Africa, women were especially powerful, and the arts reflect their prominence. When shown in couples (or paired works), women are often as tall as men (or taller). Female and male figures sometimes display complementary physical attributes or decorative elements (labrets and beards, or breasts and pectoral muscles). Motherhood is especially celebrated. In certain cases – Luba and Dahomey, among others – rulers are identified as symbolic women. Community works and area men's initiations often feature motherhood imagery. The Baga D'mba mask from Guinea (previous page) reveals such motherhood ideals, the name itself designating a woman who has given birth. An older woman's long, flatter breasts identify this carving as a prolific mother who has nursed many infants. She is identified as a family (or community) mother, and an icon of motherhood more generally. Among the nearby Mende, Sande Sowei helmet masks (opposite) are among the few masks African women wear. They are worn during initiation rites where younger women are instructed in community values and larger societal roles. Feminine beauty ideals are indicated –a wide, high forehead (intelligence, thought), compact facial features (small mouth– composure and humbleness) and beautiful neck ripples (health, prosperity and watery waves). The latter evoke the Sande spirit emerging from water pools. In past times, Sowei initiation was when female circumcision took place, for which Sowei masks were believed to promote healing.

Sometimes, older or wealthy women faced sorcery accusations. The Yoruba, rather than attacking these women, honoured them with special Gelede ('old') masquerades to celebrate these 'Mothers' (awon iya wa). Maintaining social values also factors into art making, with divination forms of varying types often central to this process. Sculptural commissions sometimes served protective roles. One such work, a Fon (Dahomey) bocio (page 30), served as a surrogate for living family members under threat, capturing harm within this figure. Some bocio possess two heads – positioned either side by side or front and back – adding to their power and protection from

Mende wood carver
Sande Sowei mask
Sierra Leone,
mid-20th century
Wood and
vegetal materials,
33 x 20.3 x 20.3 cm
(13 x 8 x 8 in.)
Minneapolis Institute
of Art

The mask surface reinforces beautiful shining black skin (health, beauty) and carefully arranged coiffure reflecting community values of plaiting each other's hair, here with V-shaped forms suggesting plant growth. The delicate Sowei dance choreography, performed in dark raffia costumes, addresses moral beauty.

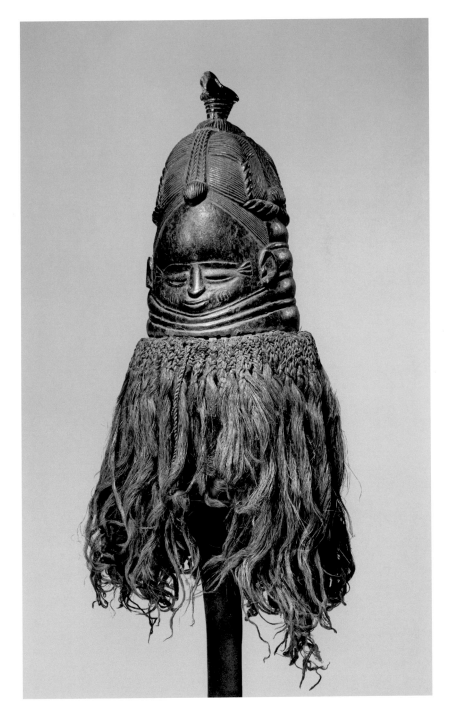

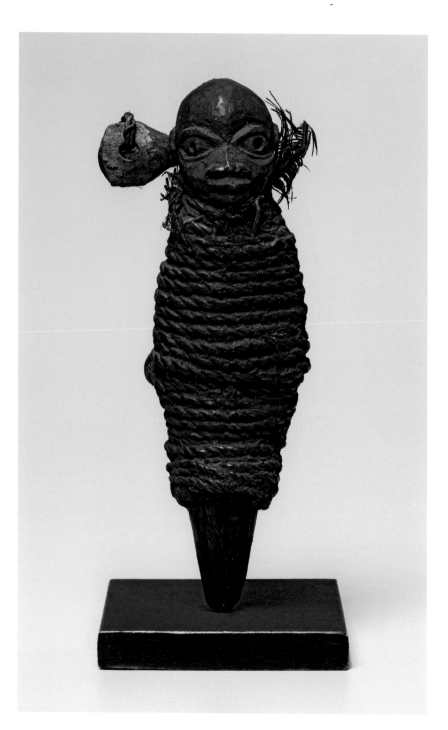

**Fon wood carver and
bocio maker**
Fon *bocio* figure
Guinea Coast,
Republic of Benin,
early 20th century
Wood, fibre and feathers,
14.29 x 4.13 x 3.18 cm
(5⅝ x 1⅝ x 1¼ in.)
Yale University Art
Gallery, New Haven

Bocio 'empowered corpse'
sculptures serve as a
kind of human 'dummy',
incorporating wooden
pegs, animal skeletal
forms, chains or cord
around a figure's body.
The pegs are inserted
into orifices – a visual
vocabulary of harm to
enhance self-protection.
The iron point at the
base is inserted into
the ground, potentially
adding ancestral voices
to the protection.

the 'four eyes' of sorcery. Similar forms of protection and healing can be traced back to far earlier traditions in African art and speak to universal ways that arts help to assuage difficulty and bring peace to an array of different viewers.

KEY IDEAS

Historic trade routes connected peoples, ideas and arts across the continent.

Even small portable art objects can have an impactful role in bringing new ideas to life.

Unusual motifs – such as sirens and Gorgons – help us discern trade-route connections.

Common motifs such as curved head rests help us to see deep, broad-based connections.

KEY QUESTION

How do these factors impact early African arts?

ANCIENT ARTS
(150,000 BCE – 499 CE)

-

**Not everything can be seen,
but everything exists**

-

Tanzanian proverb

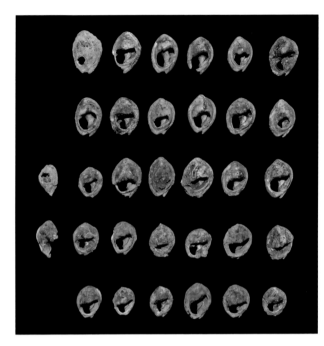

Unknown jewelry maker
33 bored shells
forming a necklace
Bizmoune Cave, near
Essaouira, Morocco,
150,000–142,000 BCE
Sea shells

**Jewelry throughout
history takes a variety
of forms. This grouping
of similar-sized seashells
bears bore holes to
insert a fibre or other
attachment means.
Resting flat against the
body, the shiny white
surfaces and rounded
natural shapes of these
objects likely served to
distinguish its wearer
from other community
members.**

All art traditions begin somewhere, and this is no less true in Africa, where humans emerged around two million years ago. They left art forms that speak not just to survival but to active visual engagement with the world. As we look back at this history we find a long legacy of creative engagement around shared themes, from body arts and depictions of nature to the importance of women, markers of place and protective mound-form shrines, rich forms of regalia and scenes of community engagement. In Africa, celebrating the past is rarely far from the present, and past members of one's family are seen to play a vital role in the lives of new and younger family members. Art is often the salve that joins the two.

The earliest evidence of body colouring (skeletal finds with ochre, iron oxide and lapis lazuli pigments) date to around 400,000 BCE in Lusaka, Zambia. The earliest known human jewelry arts, comprising thirty-three shell beads, date to 150,000 years old, and were found in the Bizmoune Cave in southwestern Morocco (above). These beads held unique aesthetic value, conveying artistic interest in beauty, prestige, family bonds and personal or group identity. Human settlements dating back to 138,000 BCE are evidenced in South African shell mounds during the height of human migration from Eastern Africa southwards. In this same region, c.88,000 BCE,

Unknown ochre carver
Carved ochre tablet
Blombos Cave, Still
Bay, South Africa,
78,000–72,000 BCE
Length about 6 cm
(2⅜ in.)
Iziko South African
Museum, Cape Town

Red ochre (hydrated iron oxide) in Africa often serves as a cosmetic body- and hair-colouring pigment for everyday occasions or ritual use (puberty ceremonies, initiations, royal investitures and funerals). Ochre also carries medicinal and symbolic value by evoking blood (symbolizing life, birth, danger and power).

at sites known today as Sibudu and Blombos, cultures rose and fell in notably rapid succession over c.5,000-year cycles, the result not of environmental crises, but of populations (and leaders) pushing known technology limits, then being replaced by others. By 80,000 BCE, the South African Cape was witnessing a notably creative period, marked in part by rapid technological change. Both shellfish mounds and large hearths reveal that sizable groups were choosing to live together, ongoing marine (fish and shellfish) protein allowed large populations to survive and thrive. At Sibudu Cave near modern Durban at around 70,000 and 59,000 BCE, major breakthroughs occurred in stone tool manufacturing, using heat-enhanced glues.

At the nearby Blombos site, an elaborately engraved ochre-coloured stone tablet (below) was found, believed to be the earliest known human drawing and dated to 78,000–72,000 BCE. The work's surface is distinguished by thin, parallel, angled line patterning, probably made with sharp flaked blades. This tablet decoration shows multi-directional diagonal lines that together form a series of diamonds, similar to patterns that later decorate jewelry forms and containers. Is this simply artistic enhancement or was the creator(s) fashioning an abstracted linear form of coded language that could be read by leading community members? Both are conceivable based on what we know about later African arts. In some ways the pattern recalls counting or calendrical sticks used by later Khoisan residents

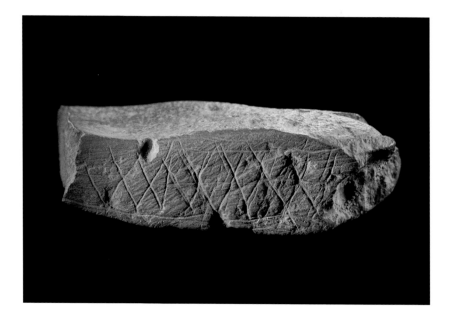

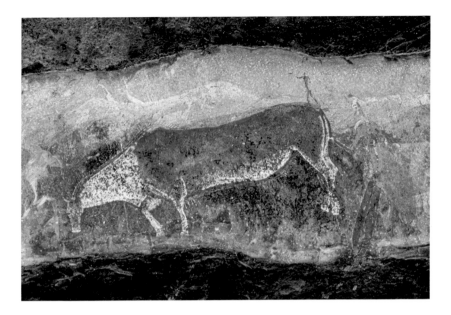

or the abstract markings on later Luba memory boards (*lukasa*) from Congo. *Lukasa* show similarly complex geometric patterns within a raised edge and served as symbolic charts, maps and mnemonic devices.

At Blombos we also find new and sharper-edged stone tools, made using hammers and pressure flaking of heated (then cooled) stone pieces to create a two-sided point. While more efficient, these knives were more fragile, and probably were ritual or prestige objects, consistent with some later African spears used not for hunting or defence, but rather in rain control roles. Blombos and Sibudu beads fashioned from tick (insect) shells were created in c.73,000–69,000 BCE and comprise datable early body decoration arts. Of the sixty shell beads from this site, twenty-seven may be from a single necklace, giving a sense that in jewelry, scale mattered. Also found at Blombos are engraved ostrich eggshell fragments (c.58,000 BCE) bearing parallel-line markings that complement modern Khoisan ostrich egg and vessel decorations.

Khoisan painter
Rock art painting of elands and human figures (detail) Game Pass Shelter, Kamberg Nature Reserve, Drakensberg, Kwazulu Natal, South Africa, c.3,000–1 BCE

A majority of southern African animal rock paintings feature eland antelopes, a species that is still symbolically important in modern Khoisan rituals. This choice means rock art imagery is not drawn from likely food sources (smaller animals), potential danger (leopards, poisonous snakes) or common scenes (birds).

-

By 40,000 BCE some African decorative shells were being traded distances 500 km (310 miles) away – communicating artistic values broadly

-

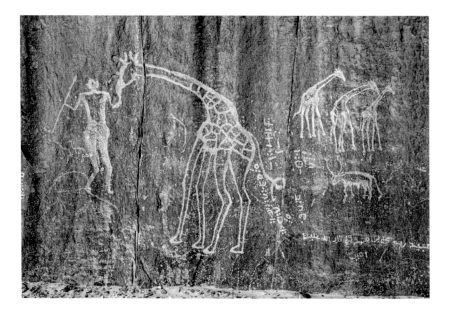

Amazigh rock engraver
Sahara rock engraving
of giraffes and humans
with writing (detail)
Tadrart (Tassili n'Ajjer),
Algeria, c.4,000–
3,000 BCE, and more
recent additions

This engraving shows
strikingly naturalistic
giraffes and hunters
engaging with each other.
In this section, a hunter
touches a giraffe nose,
indicating long close
contact. On the right,
a giraffe trio stands,
facing away, alert for
danger. Subject matter is
important for dating, but
alone does not determine
this, since animals that
appear at an early date
are also portrayed later.

Rock arts have a long history in South Africa and elsewhere.
Most of the 14,000 recorded African rock art examples, however,
remain undated. Roughly half are in southern Africa (opposite);
most others lie in the Sahara Desert. The earliest scientifically
datable example is from the Apollo II Namibia site. Some scholars
link these works to 'magic' (promoting successful hunts) or trances
(shamanic rites featuring neurological changes). Equally plausibly
these images help anchor (safeguard) power or life force after death
in an honorific visualization that impacted living area residents.
In the Botswana Tsodilo Hills, most of the c.4,500 Khoisan paintings
are found near a single mountain, the tallest of four, where, according
to local beliefs, humans were created. Water from related caves is
considered holy, believed to bring good fortune, since it is blessed by
gods who make their home here. Whatever the context, these rock
portrayals clearly reflect the artists' visual acuity, place perceptions
and religious values. Engravings (incised stone markings) and single
subject naturalistic paintings bearing red or black silhouettes are
considered among the earliest; elaborate multi-figural scenes and
more schematic human themes emerge later. Rock art dated to
around 11,000 BCE has been found near Aswan in Egypt – both
a transit route and a place where people lived.

Tassili n'Ajjer (Algeria) comprises an extensive rocky massif with
thousands of rock paintings and engravings (above). Most rock art
human portrayals display more stylization than animal depictions do,

revealing different (more abstracted) criteria for the former.
Naturalistic forms and postures distinguish many animal portrayals,
as with these giraffes. In this example, local Libyco-Amazigh script
is present. This language has an alphabet comprising twenty-two to
twenty-four letters demarked as geometric patterns (circles, squares,
lines and dots) – placed vertically as here, or horizontally from right
to left, or bi-directionally, or in spirals. This text, called Tifinagh, was
used from the Canary Islands to Libya and deep into the Sahara/
Sahel. Tifinagh has both Phoenician and local Amazigh roots, the
latter as seen in tattoos, pottery, camel brands and religious symbols.
Most early Tifinagh texts come from Amazigh Numidia kingdom
sites in Algeria and Morocco. These funerary, religious and other
texts continued into the 12th century CE, when many Amazigh began
using Arabic or Hebrew. The earliest extant Tifinagh text is a 138 BCE
Tunisian inscription, written long after Phoenicians controlled
Carthage (814–146 BCE), suggesting likely local Amazigh sources.
South of the Sahara, among Amazigh-related Tuareg, jewelry and
decorative arts still include Tifinagh letters. Children learned the
text from their mothers.

Significantly, many Sahara rock art tableaux exist at Sahara
crossing sites today. Indeed, some 35–40% of these rock art sites
are found along two main Trans-Saharan routes. Their features –
camels beginning in 700 BCE, horses from 4000 to 500 BCE –
represent key long-distance travel means and help in dating.
Saharan rock arts are divided by phases: Bulbous (buffalo) phase
(7000–4000 BCE) featuring single naturalistic animals (such as
water buffalo or elephants) and armed humans. The cattle phase
(6000–4000 BCE) includes cattle and domesticated dogs
(marking pastoral groups); elephants are still present. Giraffes,
well adapted to drier climates, date to c.4000–3000 BCE.
Next, the horse phase (4000 to 500 BCE) shows chariots from
c.1000 BCE. Horses, like camels, reflect ongoing Saharan travel
and trade activities. In North Africa, Herodotus reports that
Amazigh women sometimes had chariot battles.

Stone circles (some 1,600 in total) are scattered broadly in
Africa, linked sometimes to celestial movements and constellations,
lunar calendars and regional ceremonies. One such arrangement,
at Nabta Playa (opposite) near the southern Egypt–Sudan border,
dates to c.7500 BCE. This arrangement constitutes one of the
earliest sites of monumental architecture and is sometimes seen
as an important African precursor and model for later Pharaonic
Egyptian forms. The region around Nabta Playa was occupied for
nearly 5,000 years and the site itself emerged via various groups

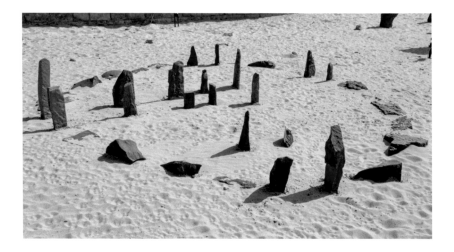

Pastoralist builders
Stone menhirs
Nabta Playa Calendar
Circle (reconstruction at
Aswan Nubian museum),
Egypt, c.7500 BCE

Like later Stonehenge
(dated c.3000 BCE),
this structure reflects
both engineering skill
and astronomy interests.
After Nabta Playa's
abandonment (c.6000–
5000 BCE), another
group arrived, building
even more complex
structures by embedding
megaliths into directional
alignment.

who migrated into the area around 10,000–8000 BCE to exploit
the nearby lake. Grain agriculture developed and new pottery forms
permitted cooked cereals. Nabta Playa originally was used seasonally;
by around 6100–5600 BCE, planned settlements emerged
featuring large hearths and deep wells, consistent with a regional
ritual centre. Cow bones here reflect African cattle domestication
6000–4500 BCE, although Nile Valley and other residents may
have hunted and domesticated wild cattle c.8500 BCE.

Cows had important utilitarian, economic and ceremonial roles.
At Nabta Playa cows were offered in a stone-roofed subterranean
ritual chamber. In time, a narrow stone slab circle with four paired
'gates' aligned north–south and east–west was erected – consistent
with summer solstice. At around 4500 BCE a large burial chamber
mound with a cow-shaped sculpture was added. Rain was vital for
agriculture and herding; but rituals marked this cycle, and they also
promoted crop vitality. On the whole, this period remained wetter
than now, and from 6000–4500 BCE herders easily traversed the
greener Sahara and Sahel, bringing new languages, cultures and arts
along with cattle, goats and sheep.

EARLY NILE VALLEY: RELIGION AND TRADE,
4400–999 BCE

Agricultural cultivation, harvesting and growing cereal such as millet,
rice and other crops encouraged new technologies, including pottery
used to prepare foods that enabled larger, denser populations to live
and work in more settled communities. In the southern Nile Nubian

areas technically and aesthetically important ceramic traditions emerged in the fourth to second millennia BCE. Some have elaborate decorative surfaces. Over a millennium or more, area rainfall declined, bringing many more people to the Nile Valley. Around 3000 BCE large structures of sundried earth replaced more ephemeral reed constructions in permanent settlements.

New technologies like metalworking introduced more change: copper smithing began around 4000 BCE and copper was transformed into jewelry, tools and weapons. Local and imported prestige metals (gold, silver) and stone were fashioned into ornamental objects for the elite and priests. Flax introduced in Egypt c.5000 BCE brought new clothing styles and decorative changes. A series of dynasties emerged here along the life-giving Nile, each comprising a line of rulers in a separate family group. A new governance and religious system were introduced, joining the political and priestly hierarchies, who commissioned and financed increasingly monumental architecture and art works that reflected increased power differences. The earliest evidence for kingship is about 3500 BCE, and for priestly hierarchies around 3200 BCE – although both are more typically third millennium phenomena.

Egyptian sculptor
Palette of Narmer,
front and back
Hierakonpolis,
c.3200–3100 BCE,
1st dynasty, Siltstone,
c.64 x 42 cm
(25¼ x 16½ in.)
Egyptian Museum, Cairo

Along the top of both sides are horned heads signifying 'heaven' (the goddess Bat). Narmer's name is notated by a catfish (African lungfish) and a chisel within a palace enclosure. Two giraffe-like serpopards (leopard/serpent forms) with intertwined necks define the recessed area for preparing the cosmetics.

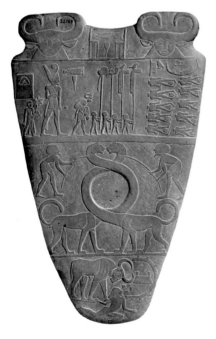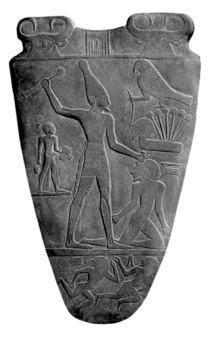

The *Palette of Narmer* (opposite), dedicated by an Egyptian ruler of that name, highlighted military, religious and administrative engagements addressing this power change. The work, carved from grey-green stone, dates to 3200–3100 BCE and served as a palette for grinding cosmetics worn by kings, commoners, as well as deities and statues. On one side, Narmer, referenced by the bull, tramples on foreigners (bodies, some with decapitated heads). On the other side, he grasps a kneeling foreign man by the hair. The Pharaoh's crowns worn on the two sides are different – but both appear to come from the Upper (southern) Nile. The palette's interpretations vary: an historic event (the king defeating enemies) or a ceremonial reference (celebrating this or another event) or a scene of cosmological order (unity and chaos) are the most frequently cited. The imagery is currently believed to reference the daily rebirth of the sun (Re), an event where ritualized consumption and a barque (boat) figure prominently at the top of the side shown on the left. Whatever its meaning (and perhaps it has many), this small yet monumental work that most likely was intended for a deity audience and shows the long legacy of body art cosmetics.

Egyptian expansion into Nubia dates to the Middle Kingdom (2040–1650 BCE) and occasionally earlier, but Nubia's boundaries with Egypt changed over time up and down the Nile, measured by its cataracts. Elephantine, one of these longest-established border sites, was a religious, political and trading centre. It was situated near the First Cataract, about midway between the Nile Delta and the capital of the later (750 BCE to 300 CE) Napatan-Meroitic state, Meroë. Nubia's heartland extended from Elephantine south to the sixth Nile Cataract near Khartoum (in modern Sudan). Sometimes cataracts made the Nile River nearly un-navigable, requiring portage, so skilled Nubian boatsmen were critical to north–south gold and exotic goods trade. Measuring seasonally rising water on the Nile was vital to sustaining Nile-adjacent life, determining many activities, especially planting, harvest and taxation. A water measurement system (Nilometer) carved into Elephantine's living rock calculated the river's rise and fall, reflecting annual rainfall variables based on Ethiopian highland riverine sources. The Nilometer was positioned near the temple for Khnum, the ancient ram god credited with yearly Nile inundation, life (creation of human beings) and buildings (from wet Nile earth or local stones floated downstream). It was in a cave near Philae, a little further south, that some thought the Nile's waters originated. Khnum guarded the Nile water's assumed origins that enabled yearly flooding, adding fertile black river silt along with vital water needed

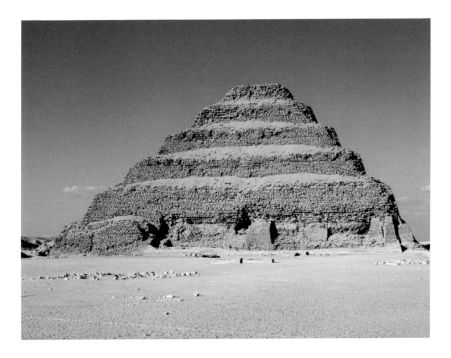

for drinking, agriculture, ceramics and building. A nearby Nilometer honours Khnum's wife, the fertility goddess and huntress Satet, and includes scenes of inundation.

Nubia's famed archers contributed to both Pharaonic Egyptian and Nubian history, a skill suggested in Egypt's name for Nubia's Kush Kingdom (Ta-sety, 'land of the bow'). They were one of several Nubian groups – militia, traders, artists, administrators – that transformed the Nile Valley. One of the ways we can explore this cultural richness is through the intersections between families, religions and art. Nubian Queen Tiye (c.1398–1338 BCE), grandmother of Tutankhamun and mother of the even more important Pharaoh Akhenaten, had major political power and influence in Egypt. Queen mothers feature prominently in African art and court life, and she was no different. Queen Tiye's father was a wealthy chariot commander and landowner; her own mother sang in several temples and may have been royal. Her brother was a priest of Amun, the ram-form high god complementing Khnum. Tiye's husband Amenhotep III honoured his beautiful wife with numerous portraits and temples.

Along the northern Nile, at Giza, 10 miles from modern Cairo's centre, stand the famous group of pyramidal tombs created by

Egyptian builders
Stepped Pyramid
of Djoser
Saqqara, Egypt,
c.2630 BCE

Pyramids reflect the development of elevated political power. Monumental architecture, much of it in the form of funerary memorials and later temples, reflects the cycle of life – the Nile flooding and role of priests as deity intermediaries who undertook annual rituals at these sites, addressing these and other issues. In months without rain, large-scale ceremonies and celebrations used these structures as beautiful backdrops, though access to interiors was very limited.

Old Kingdom rulers. The pyramid of 4th-dynasty Pharaoh Khafre (Chefren – c.2558–2532 BCE) was one of many Nile monuments. Smooth-sided pyramids were the norm, although the earliest pyramid tomb, built for the 3rd-dynasty Pharaoh Djoser (2650–2575 BCE – opposite), is stepped. These northern Nile pyramids are striking in scale. In southern Nile Nubian areas (in modern Sudan), double the number of Egyptian pyramids were built, although they were smaller. Pyramids of both areas share important connections with hollow conical African religious shrines that provide protection for spiritual forces that enable life. Roofed pyramid and temple portals recall rudimentary meeting shelters where elders gather. As in many later African buildings, a strong sculptural element prevails in Egyptian temples and pyramids. The nearby Giza Great Sphinx erected for Pharaoh Khafre constitutes the world's largest monolithic sculpture. In its east-facing (sunrise) and Nile-facing orientation, this anthropomorphized feline-human sculpture complements later African zoomorphic sculptures and cosmological interest.

Scholars debate how pyramids were built. Massive stones were floated downstream on rafts and slid overland on timber rollers. The raising of pyramids included construction ramps of earth and pulleys. For Pharaoh Khufu's tomb, the main ramp used to haul up the stones was positioned beneath the outer surface (a pyramid within a pyramid). The lowly dung beetle, credited in Egyptian myth with pulling the sun across the sky each day, perhaps provided a model for such work. These beetles push their far heavier egg-containing dung balls uphill backwards, using their back legs and feet for leverage. That life (eggs, babies) emerges from seeming foul forms (dung) evokes ideas of cosmological transition and generational death and renewal. Dung beetle scarabs are important in Pharaonic arts, crafted from expensive stones and gold.

Khnum, as creator god, is depicted in stone reliefs and other arts with long ram horns. Khnum's image appears early, and also towards dynastic Egypt's dynastic end (overleaf). The form reappears in Nubian royal forms and archaizing medieval Christian rulership contexts (when older mythologies and traditions were revitalized). The Amazigh and other northeastern African cultures had ram gods as well. Khnum's home of Elephantine (locally called Abu – elephant) was a main cargo transfer site for goods traded on the river and from elsewhere. The name reflects the site's importance as a trading centre for ivory and other valuables, including key resources from the south and west – gold, copper, prized coloured stones, expensive plant products, dark ebony woods, exotic animals

Egyptian carver
Temple relief fragment
of the god Khnum
Egypt, 19th dynasty,
New Kingdom,
1292 BCE to 1190 BCE
Limestone, 46 x 53.5 cm
(18⅛ x 21⅛ in.)
British Museum, London

**The god Khnum aided
artisans, creating
everything from boats,
ladders and pots to
buildings. Khnum
remained key to Nubian
identity. Khnum's main
Nubian temple site,
Elephantine, lies 70 km
(43 miles) north of
where the sun seemingly
reverses directions, at
winter and summer
solstices.**

and humans. Financial resources and tributes that Nubians provided
were critical to Egypt's economy and building projects. Elephantine
also had important stone quarries, which boast one of Egypt's
largest obelisks ever initiated, commissioned by the 18th-dynasty
female king Hatshepsut (reigned c.1473–58 BCE); the unfinished
monument remains frozen in time.

Like one or more earlier Pharaohs, Hatshepsut sent a well-
organized exploratory and commercial expedition to find new
external trade connections – down the Red Sea to 'Punt' (eastern
Africa or Arabia), thus by-passing Nubian middlemen and gaining
access directly to Africa's interior. She commissioned a mortuary
temple, Deir el-Bahri, with richly painted murals that illustrate
this expedition and its finds – gold, monkeys, leopard pelts and
myrrh resin-bearing trees (to be planted for healing, cosmetics,
temple incense and embalming rites). On the tomb of Hatshepsut's
favourite Senenmut is the earliest extant constellation chart,
providing information that was important for planning ceremonial
activities and travel.

Hatshepsut's expedition returned with a local Punt queen
(opposite) depicted in a style quite atypical of Egyptian figures.
While the ethnic identity of Hatshepsut's African queen is unknown,
she was described as quite heavy, as evidenced in this portrayal.
Hatshepsut, who became regent after the death of Thutmos II
(her husband) and later proclaimed as Pharaoh, chose to self-

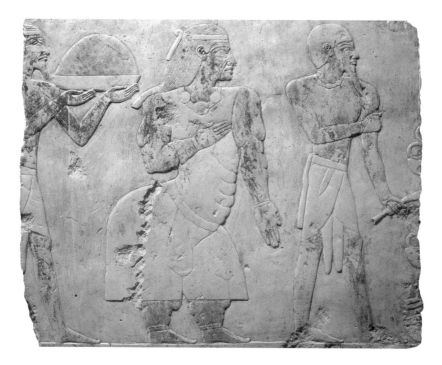

Egyptian painter
Painted relief of Queen Iti, co-ruler from Punt Hatshepsut's mortuary temple, Deir el-Bahri, Egypt, c.1473–58 BCE Egyptian Museum, Cairo

Artists were much freer in portraying outsiders such as the Punt queen. Had she been Egyptian, the rendering style would be closer to the other (Puntite?) figures walking before and after her – the latter holding a vessel mounded high with gold. Her heavier features – buttocks, belly and rippling arms – would rarely appear in Pharaonic royal portrayals.

identify with male rulership, often depicted with a wedge-form male beard and kilt-like skirt. Hatshepsut was one of Egypt's most powerful female rulers. After Hatshepsut's reign, the successor, a nephew, destroyed many such portrayals.

LATE DYNASTIES, PTOLEMAIC, BROADER AFRICAN AND INTERNATIONAL DEVELOPMENTS (1000 BCE – 499 CE)

In the Third Intermediate Period (beginning c.1070 BCE) regional rulers gained Pharaonic power and these regional engagements prepared the way for Nubia's Egyptian takeover. Libyan rulers (ethnic Libyan Amazigh who were settled in Egypt) assumed increasing power about 1000–700 BCE. From c.715 BCE Nubian rulers controlled the entirety of Egypt, taking up the traditional Pharaonic titles, fashions and burial customs of historic Egyptian rulers. Like their predecessors, they commissioned massive building projects here, reinvigorating earlier Egyptian religious forms and participating in an artistic resurgence, often in Old Kingdom style.

The new southern Pharaohs often retained native Nubia-linked names while adding Egyptian prenomens. While the order of kings is disputed, among the notable ones were King Shabaka (721–707/6 BCE)

and King Taharqa (690–664 BCE) (below). King Taharqa's sculptures often incorporate ram's head amulets, a reference to Amun-Ra, now a pseudo-monotheistic high god. Perhaps because military success was often credited to this god, medieval Nubian Christian rulers also depicted the ram deity with royal regalia, a tradition that has its origins in the earlier Meroitic period and seems to have been carried further west to the Niger River.

In 671 BCE, the Pharaonic capital Memphis (now Cairo) was sacked by Assyrians from the east. King Taharqa was forced to flee. The 26th dynasty itself ended in 525 BCE with civil war following

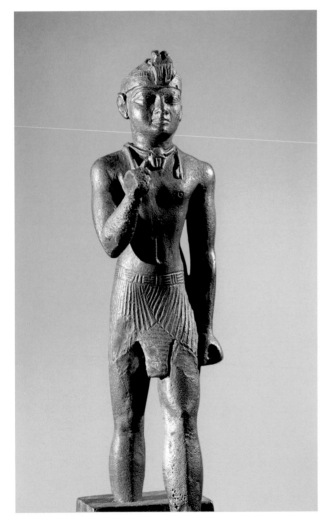

Egyptian bronze caster
Figure of King Taharqa
Egypt, 25th dynasty,
690–664 BCE
Bronze, height
8.5 cm (3⅜ in.)
State Hermitage
Museum, St Petersburg

King Taharqa's upright posture, set eyes, formal forward-striding stance and idealized youthful adult rendering are characteristic of Pharaonic depictions. What sets these Nubian royal figures apart from earlier Egyptian royal exemplars are both symbolic elements and subtle elegance.

Nubian jeweller
Ballana Nubian crown
Sudan, 370–400 CE
Silver and precious stone
Egyptian Museum, Cairo

**Worn by Nobadian
(late Nubian) rulers,
this crown with its
prominent horn shapes
both harkens back to
earlier Khnum/Amun-Ra
religious and dynastic
idioms and forward
to Christian and other
traditions. Along the
rims are references to
the Kushite gods Uraeus
and Horus.**

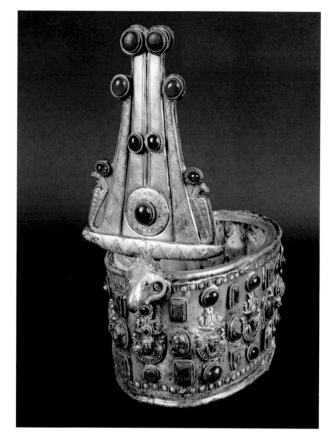

the recent Persian conquest of Egypt (they remained in power
until 404 BCE). Other international intrusions became increasingly
impactful, especially when Macedonian/Greek leader Alexander the
Great (356–323 BCE) founded a new capital at Alexandria, Egypt's
port, in 332 BCE, and a new Greco-Roman and more internationalized
Egyptian era began, with Ptolemy I Soter (reigned 305–c.285 BCE).
Historic Nile Valley artistic traditions also were part of this era's visual
sources, as seen for example in the 370–400 CE Ballana Nubian
crown decorated with ram's heads and plumes (above).

A truly international art period with strikingly empowered
objects emerged around 330 BCE to 330 CE drawing from the
earlier cults of gods and goddesses such as Isis (addressing women,
fertility, harvest and the underworld) and her son Horus (overleaf).
Isis is linked (as wife/sister) to Osiris, who rules in the afterlife and
references death, rebirth and the fertility cycle. According to legend,

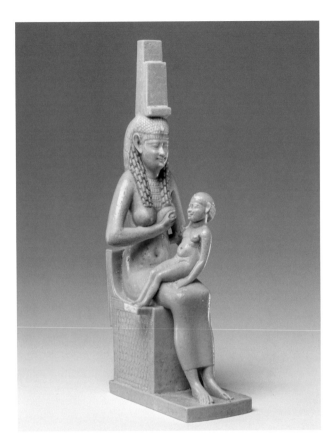

Egyptian artist
Figure of Isis and Horus
Egypt, Ptolemaic Period,
332–330 BCE
Faience (glazed frit),
17 x 5.1 x 7.7 cm
(6¾ x 2⅛ x 3⅛ in.)
Metropolitan Museum
of Art, New York

This Isis votive sculpture shows Isis nursing her son Horus (the sky god). Isis imagery dates to early Old Kingdom Egypt and her role as Horus's mother identifies her in some ways as the symbolic mother of Pharaohs. Politics and religion remained closely tied and even Egypt's last Ptolemaic ruler, Cleopatra VII (51–30 BCE), wore Isis attributes – a sun disc and horns.

Isis not only resurrects her slain husband Osiris, but protects her son and heir Horus by hiding him in the marshes until he is old enough to claim the throne (and avenge his father). Isis's imagery nursing Horus thus symbolizes rebirth and resurrection, bringing health to devotees and aiding the deceased in entering the afterworld. Some of this imagery is taken up in Christianity, impacting early portrayals of Mary and Jesus in Egypt and elsewhere. The three Magi, bearing gifts of myrrh, frankincense and gold (often Nubian-sourced goods), also reveal links between Egyptian and Nubian traditions and Christian ones that emerged from this rich African religious ground as well as from traditions in the Middle East.

Other transformative forms predominated in Egypt and the broader area as a more international period unfolded. One especially significant corpus of works are miniature cippi, sculptures that travelled broadly and had important impacts. Composite imagery engaging Egyptian protective household gods like Bes (the dwarf

Egyptian stone carver
Cippus of Horus stele
Egypt, Ptolemaic Period,
2nd–1st century BCE
Stone, 25.5 x 14 cm
(10⅛ x 5⅝ in.)
Collected by James
Bruce in Ethiopia in 1771
National Museum of
Scotland, Edinburgh

**These miniature but
monumentalized
sculptures encapsulate
ideas from Egypt's rich
legacy of ritual power,
invocations and spells.
Such works protected
or helped those facing
harm or change, drawing
from Egyptian and other
African ideas of healing.
This object, collected in
Ethiopia, shows how far
such works travelled.**

deity) alongside fish/crocodile-legged forms more akin to sirens, composite figures standing atop crocodiles and Abraxis magical gems are frequent. In the cippus (below), the central figure of Horus subdues dangerous animals (some grabbed by his hands, others beneath his feet). He stands beneath Bes (or a Gorgon-like form), victorious over all evil and danger. Such works often include glyphic texts with recipes for protecting one from evil, exorcising devils or healing. In some examples, water poured over the sculpture served as libation or had a curative function. Manuscripts from this era and later include invocations and both ritually and physically transformative ideas (among these, protection and alchemy).

Regeneration and transformation interests continue in later religious arts, including Ethiopian healing scrolls and Coptic (Egyptian Christian) magic-linked manuscripts

All these political changes brought major transformations to the Nile Valley and elsewhere, particularly as Nubia and Egypt as power

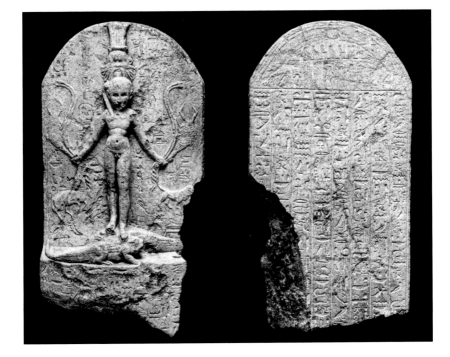

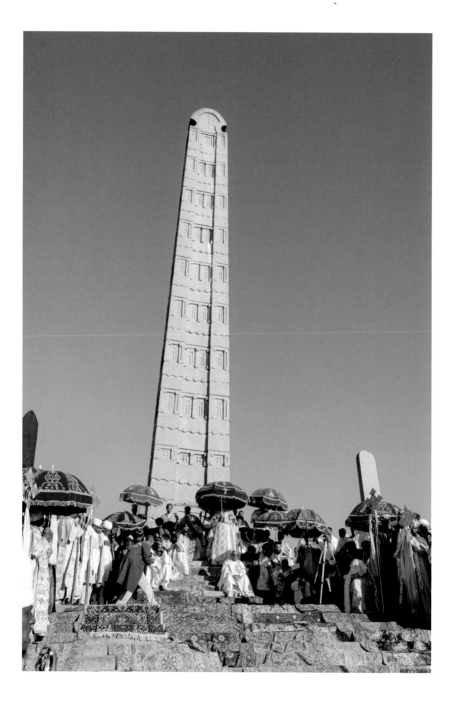

Ethiopian stone carvers
Aksum stela
Ethiopia, 3rd–4th
century CE
Backdrop for a Maryam
festival with an assembly
of the Church patriarchs
and archbishops

**Aksum dominated the
inland African and
international ivory
commerce; its boats
dominated the Red Sea
trade. In 525 CE, under
King Kaleb, Aksum
gained a foothold
in southern Yemen,
controlling this area
for nearly 500 years.
Aksum's mints furnished
coins that have been
found as far away as
southern India and
eastern Roman Empire
sites including Israel.**

bases were dissipating. Other powers moved into the vacuum.
From the 1st century CE, the Aksum kingdom replaced core Nubian
control of main trade routes and became the most powerful polity
between the Roman Empire and Persia. Through the 3rd century,
Aksum was considered one of the three greatest world powers, with
its trade routes extending to both India and Rome as well as spanning
what is today eastern Sudan, Djibouti and Eritrea. Stone menhirs
and obelisk traditions in Pharaonic Egypt inspired complementary
forms in the Aksum Kingdom (opposite) and elsewhere.

Aksum became well known in the 3rd and 4th centuries CE for its
array of giant carved stone stelae and obelisks – the tallest reaching
33 m (108 ft), the largest such work ever attempted – alongside
impressive tombs and castles. Stylized stela doors decorating the
surfaces recall Egyptian mortuary tomb portals. Stone tablets
here sometimes include texts in three languages – Ge'ez (ancient
Ethiopian), Sabaen and Greek (utilized in the 4th century under
King Ezana). Under this same king, Christianity was introduced in
Aksum, and with this change, the stelae construction programme
ended, replaced by churches. Aksum's hegemony began to decline
in the 10th century, although Ethiopian emperors continued to be
enthroned here. Eventually, under attack by the Rashidun Caliphate,
the first to emerge following Muhammed's rise to prominence, and
due also to altered trade-route controls, a 9th-century famine,
and the 960 CE attack by an outsider Jewish Ethiopian queen
(Gudit), Aksum's capital was moved inland, where its residents
and rulers remained Christian. Today, Aksum remains Christian, and
many related rituals are now performed in Aksum stela shadows.

Like Aksum arts, those in North Africa reflect a combination
of forms and influences. Amazigh impacts continued through
Carthaginian, Roman and Byzantine expansions, with North
African arts often retaining African roots. Mosaics from the Roman
occupation era are generally bolder and more colourful than others,
complementing local aesthetic and cultural values. The c.2nd-
century CE Libyan mosaic masterpiece known as the Zliten Mosaic
(page 53), from a Roman seaside villa, is made up of diverse scenes
of Roman musicians (some playing African instruments such as the
xylophone and harp), as well as gladiator matches (often featuring
local Amazigh fighters – among these southern Garamante
residents), human–animal and animal–animal combat scenes, animal
hunts and battles to capture other humans (enslavement). Wrestling
matches have a long history in Africa (from Egypt to Nigeria to
Senegal and beyond) and sometimes the arts show these events.
While the mosaic artists' identities are not known, in later eras,

European patrons often employed local Africans to fashion prestige arts at home. Could Amazigh Roman-period artists have created such works? Were they patrons or viewers in Roman and post-Roman periods? While further work needs to be done, we have ample evidence of Amazigh interest and skills in rock arts and their astute eye for naturalistically depicted animals and action-based scenes.

Some rulers within the Roman Empire were of Amazigh origin – for example, Juba II (c.48 BCE –23 CE) who ruled Numidia and accompanied Julius Caesar on his return to Rome. After learning Greek and Latin, he authored books ranging from history and painting to archaeology and natural history. He also sent exploratory expeditions to the Canary Islands and Madeira. Other prominent Amazigh individuals affecting African and world history include military leader Hannibal (247–183/181 BCE), born in the Libyan/Phoenician-linked port city of Carthage, who crossed the Strait of Gibraltar with elephants, reaching the gates of Rome. St Augustine (354–430 CE) and several early Catholic popes were also from African Amazigh communities, shaping Christian religious tenets in Africa and elsewhere, as were the founders of the Muslim Zirid and Almoravid dynasties, who helped fashion Muslim North Africa, Spain and Sicily. Once dominant Christian communities in North Africa eventually converted to Islam and with the Nile Valley even non-Arab Amazigh populations (including many who remained Christian) often spoke Arabic as a new lingua franca.

From around the 5th century BCE to the 7th century CE, the powerful Amazigh-linked Libyan Garamante state rose to power in the then less dry central Sahara. African regions remained critical to Rome as suppliers of food and trade goods such as wood and dyes. At its height in the mid-2nd century CE, Garamante power embraced nearly 181,000 square kilometres (70,000 square miles). Defined by complex irrigation systems (called qanat or foggaras), Garamante also created tunnels and mineshafts, enabling residents to access water deep beneath Sahara sand. This unique irrigation system (which Morocco Amazigh later embraced) supported a large, dense population and a rich agricultural economy enhanced by iron tools. Pyramids of saline-rich clay resembling Nubian forms functioned as memorials, suggesting – as with Juba II's pyramidal funerary monument – the legacy of Egypt and other African shrine traditions. In 569 CE, the Garamante ruler, then partnering in the Byzantine trading network, converted to Christianity.

To the south, in modern Nigeria's Jos mountains and plateaus north of the Niger–Benue river confluence, the art-rich Nok culture emerged. Founded around 500 BCE, Nok came into its

Roman or Amazigh Mosaic artists
Zliten Floor Mosaic panels
Libya, 2nd century CE
Archaeological Museum of Tripoli

Garamante Amazigh, who had frequent military encounters with Roman colonial authorities, were also key trading partners, offering wheat, salt, wild animals and tribute-linked captives in exchange for foreign goods – olive oil, wine and ceramics. By 668 CE, with new Islamic pressures, Garamante converted to Islam.

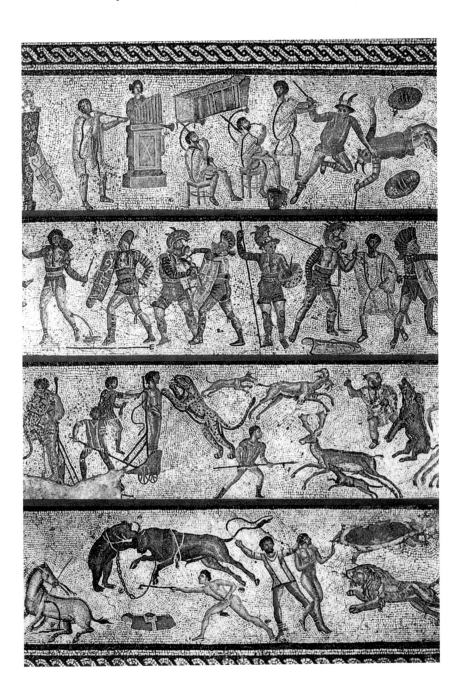

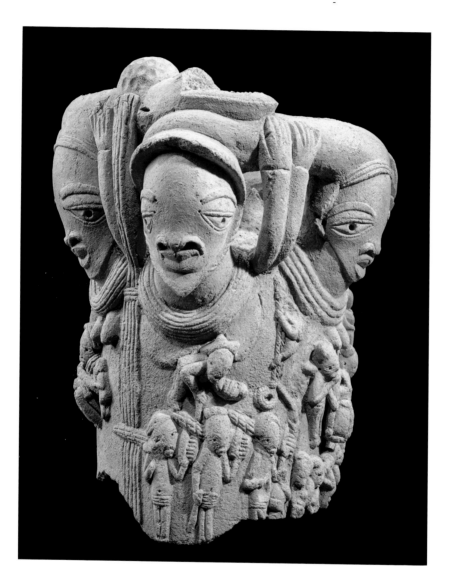

own as the Garamante and Ptolemaic (Greco-Roman) era came
into primacy, replacing the Nile Valley Pharaonic era further west.
The stunning Nok terracotta art works (above) date to between
c.500 BCE and 200 CE, a period when ironworking was important,
not only in making tools for agriculture (millet, cow peas), hunting
and other work, but also for decorative arts. Iron, ivory and other
trade goods were likely exported north across the Sahara, south
into the Niger–Benue, and east to the Nile Valley. Although Nok

Nok ceramic artist
Nok caryatid vessel stand
Nigeria, 500 BCE to
200 CE
Terracotta, height
50 cm (19¾ in.)
Pavillon des Sessions,
Musée du Louvre, Paris

**This vessel stand features
a large multi-community
or court-associated
festival with groups of
people, a seated mother
and child, music (large
drums), a procession,
feasting (a person with a
mortar, another holding
a closed container)
and a possible tribute
(a person holding long
bars). The raised arm
caryatid gestures of
the paired larger male
and female figures
suggest the possible
use of this object as a
stand, and/or a prayer
gesture consistent with
ceremonial use.**

was a dispersed Iron Age culture, stone continued in use – stone axes, grinding stones, as well as stone beads fashioned from quartz, carnelian, jasper and chalcedony. Red ochre remains reveal body decoration practices.

Nok terracotta sculptures, some nearly life-size, were created as hollow coil-built figures with details carved on wet clay surfaces that were slip-covered and burnished before firing. Subjects include male and female human figures in diverse postures, often with distinctive hairstyles, jewelry and clothing. Other works include animals (elephants, felines and snakes) as well as zoomorphic humans or humans with congenital conditions or diseases. Some figures display specific activities such as manning a group canoe, hunting with slingshots or bows and arrows, and communal feasting. The dugout canoe imagery indicates Niger or Benue river transport and trade, as part of a larger regional exchange system. Significantly, one of sub-Saharan Africa's longest canoes (carved from one immense tree trunk) was unearthed in north-central Nigeria. It dates to the 1st millennium BCE, reinforcing the importance of riverine trade, as does a 6500–5950 BCE canoe from the northern Nigerian site of Dufana. A seashell found here indicates that Nok trading contacts likely reached the Atlantic.

Scenes shown opposite complement forms found in both African royal traditions and more acephalous (stateless) communities. Considering Nok art stylistic similarities across long distances and time, as well as the striking elaboration of coiffure and jewelry, these works may reflect an areawide Nok kingship or similar hierarchical context, although, like many world contexts through history, such a system no longer exists. Leaders drew on new iron technology forms for advancing farming, hunting, war and trade – activities often enhancing hierarchy and control.

Some Nok terracotta sculptures, among these an elephant head, may reflect the hunt for ivory, which some scholars hypothesize promoted early African state formation by uniting hunters from multiple communities to block area mountain passes as hunts unfolded. These hunters then united to divide meat and ivory. The latter went to the leader, while the body was divided among various participating communities. Nok art details evoking wealth and individual identity comport with this. Central African kingdoms (Bamun, Kuba and Luba) display similarly diverse coiffure and decorative arts in royal contexts. The capitals, built of ephemeral materials, frequently moved from one site to another.

Turning south, below the Benue River system and east of the Niger are found headwaters of the Cross River between modern

Nigeria and Cameroon. Here around thirty stone menhir circles (containing about 300 individual carved stones) were created, many remaining today (opposite). These sculptures (*akwanshi*, meaning 'ancestor stones') stand between 30 cm and 1.8 m (1 and 6 ft) tall, and date from the 3rd to the 16th century CE. Their forms evoke stylized humans with distinctive faces, navels and body decoration patterns such as keloids. Some also show the local symbolic writing form, *nsibidi*, referencing community values – with symbols like human figures alone or with others, and details such as doors, musical instruments, masks and natural phenomena. Similar pictographic forms appeared historically in juridical rites, carried out by local men's 'leopard societies', known as Ekpe, who held important area judicial and executive powers. This ideographic writing focused more on philosophical and social values than the spoken language complements in Libyco-Amazigh writing forms.

The Cross River Region also carries broader historical importance. This general area saw the emergence of the Benue–Congo branch of the Niger–Congo language family, and it is seen as the homeland of the 400 Bantu languages and technology cluster that migrated south c.2000 BCE into the Congo and nearby regions, and further east. Bantu may have functioned as a 'trade/economic language' cluster (comparable to Afro-Nilotic and Kiswahili Bantu) for people carrying new technologies – ironworking, ceramics and agriculture – and more permanent settlement forms into the regions long associated with other populations and economies – such as Mbuti ('Pygmy') and others. DNA evidence reflects a conjoining of newly arriving Bantu technology purveyors with local populations, rather than a large-scale migration, one that reframed the local economies and brought other cultural elements. The Bantu languages helped enable this movement and transformation, but arts of the broader Congo and Bantu area show remarkable diversity of form (pages 108–14). Because Bantu speakers also share certain concepts related to medicinal and ritual arts, such as the Nganga healer, this suggests that factors of health and healing (perhaps linked to iron and new rituals) contributed to the cultural toolkit being circulated and adopted here. We also see here the primacy of blacksmiths as community leaders and culture heroes. Mobility features prominently even in new farmland communities, palace centres or cattle grazing areas.

Cross River stone carver
Cross River figural
monolith
Ejagham, Nigeria,
3rd to 16th century CE
Stone, 57 x 22 x 25 cm
(22½ x 8¾ x 9⅞ in.)
British Museum, London

**Still in use long after they
were made, some of the
design elements of these
stone menhirs appear
on later-era masks of
the Ejagham and other
Cross River peoples, as
well as nearby Igbo arts –
local textiles, calabash
gourds and wall paintings
conveying messages.**

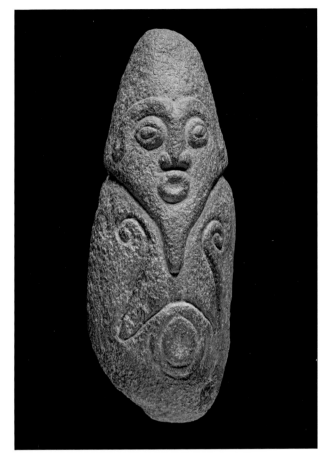

KEY IDEAS

African arts prominently address questions of cosmology, celestial
movement and rain.

Wild and domestic animals are important sources of symbolism.

When the Pharaonic Nile Valley power hold dissipated, other
regional political and trading centres emerged to the south
and west.

Global religions – including Christianity and Islam – feature
early on and are shaped by Africa.

KEY QUESTION

As new technologies made more and more densely populated cities
possible, how did art production change?

MIDDLE AGES:
A GOLDEN ERA
(500–1449 CE)

-

**By going and coming,
a bird weaves its nest**

-

Ghanaian proverb

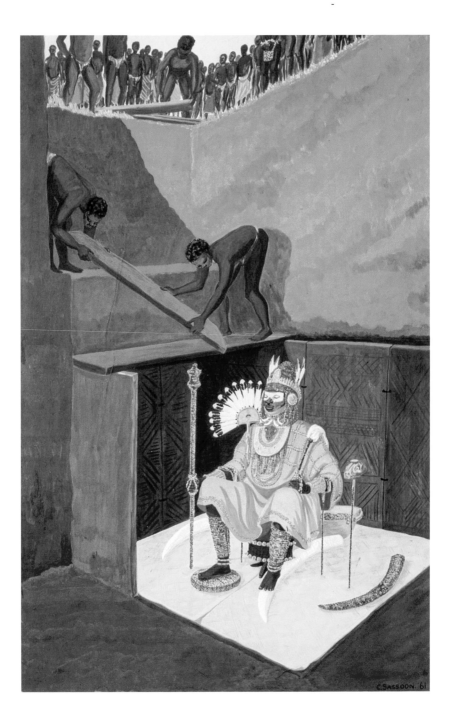

Caroline Sassoon
Painting of archaeologist
Thurstan Shaw's tomb
reconstruction with
seated leader and
grave goods
Igbo Ukwu, Nigeria, 1966
Gouache, 50.8 x 35.6 cm
(20 x 14 in.)

**Igbo priest-rulers oversaw
ritual, economic and
political issues important
to the larger Nri Igbo
sub-group. Goods
buried here and in a
related storage pit show
remarkable variation
and technical mastery,
including the first West
African lost-wax casts.
Copper, iron and other
metals are likely from
nearby mines.**

Africa's Medieval era saw extensive travel and trade across the continent and beyond. In many ways this was an African art 'Golden Age', an era marked by complementary artistic brilliance with gold and other goods entering global markets. Major trade centres and states emerged, along with new, monumental architecture in earth, stone and other materials, as well as broader use of transformative technologies such as lost-wax metal casting. Some African medieval bronzes (a term for all copper alloy sculptures during this period) rank among the finest anywhere, surpassing ancient Greece and Rome, Renaissance Europe and Asia technologically. Africa was among the wealthiest of global arenas and both artistic commissions and creativity reflected this. With Christianity and Islam's emergence, both with strong footing in and impacting Africa, we see local African values and interests shaping religious tenets and visual expressions. The untimely end to the Medieval era was the Black Death (1346–53), which reached not only Asia, the Middle East and Europe but also the Nile Valley, North Africa and Africa's interior, bringing death and related economic and social difficulties to centres like Ife (Yoruba) and Mali involved with international trade.

THE NIGER–BENUE CONFLUENCE AREA

Among the most vibrant areas of medieval engagement were Niger–Benue river-affiliated centres in modern-day Nigeria. Here Igbo civilization emerged and found expression (opposite) in remarkable art works in Igbo Ukwu sites dated 9th through 13th centuries CE. One such Igbo Ukwu site served as burial ground for an elite priest-ruler who had Nri affiliation. The priest-ruler held divine authority over the population, possibly comparable to Christian Nubian priest-rulers in the southern Nile. Igbo Ukwu arts include portrait sculptures, wild and domestic animal forms, staff mounts, altar stands, jewelry and containers, including a rope-enclosed vessel form (overleaf). Complementary examples include medieval Nile Valley (Muslim and Christian) water vessels fashioned from stone. Water was poured into the vessel, with dirtier water settling to the bottom. Knotted rope served as both vessel carrier and protector. While clearly referencing this tradition, the Igbo Ukwu work is unique because it is a copper alloy casting, showing how ideas can travel widely and be strikingly refashioned. The work also is important because African vessel-form arts have a long history and, like figural arts, technical, material, aesthetic and use considerations are vital factors not seen elsewhere.

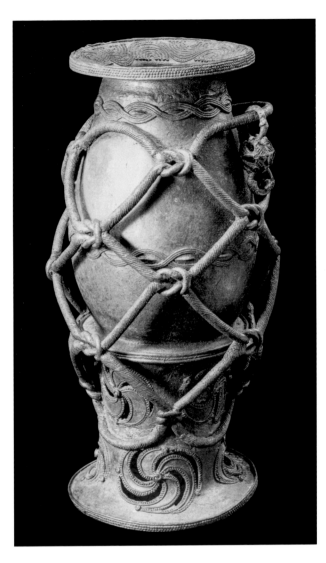

Igbu Ukwu bronze caster
Roped vessel on a base
Igbo Ukwu, Nigeria,
9th–13th century
Copper alloy cast,
height 20.3 cm (8 in.)
Nigerian National
Museum, Lagos

**Igbo Ukwu bronzes pop
with elaborate surface
detail enriched by
geometric and insect
motifs. This vessel is
a work of stunning
complexity. This work,
cast as one piece,
comprises a globe-shaped
pot secured within a
protective crisscrossing
rope, resting on
a supportive open
work stand.**

Thousands of glass and carnelian beads (over 165,000 examples – some monochromatic, others striped) found at Igbo Ukwu were both locally made and imported, revealing long-distance trade sources east to the Nile Valley and possibly India. Some of these glass beads have chemical properties identical to medieval Ife Yoruba ones. Many Igbo communities today are organized around a title system, the Nri, where elders choose a new leader after a seven-year interregnum. The Eze Nri derived supernatural qualities

from undertaking a symbolic power-enhancing journey when he received his sceptre and visited the main shrines and deities. The rite concluded with his symbolic death and rebirth. Distinctive diagonal facial marks (called *ichi*) were incised on the Eze Nri, his daughter and titled leaders. These marks have been described as a ritual purification that also honours the sun (or moon) as well as the Earth Goddess Ala. Eze Nri held important juridical functions in cases of dispute and performed ceremonies to encourage community harmony. He cleansed the earth where crimes were committed and promoted bountiful yam harvests. During annual Nri festivals, delegates arrived with tribute as a sign of loyalty, in exchange for blessings and medicine encouraging crop fertility and other benefits.

The Ife Yoruba centre, situated to the northwest of the Igbo, has its own remarkable bronze casting traditions. Like the Eze Nri, Ife's ruler (the Ooni, regionally once called the Ogane) was a religious and political leader. The medieval Ife King (Ooni) Obalufon II (c.1300 CE) is especially renowned. The life-size *cire-perdu* cast mask (below) that personifies the ruler Obalufon II was housed in the palace coronation shrine until the mid-20th century, when a new museum was built on the palace site. According to Ife oral traditions,

Ife bronze caster
Ife (Yoruba)
Obalufon mask
Nigeria, c.1300
Copper, height
33 x 17.4cm
(13 x 6⅞)
Nigerian National
Museum, Lagos

King Obalufon II serves as Yoruba's god of bronze casters, textiles and good governance. Obalufon, personified in this mask, is credited with enlarging the economy, promoting Ife's trading network and assuring safe passage. He founded Ogboni to address trade-related issues. He also created a new palace and a city-circumscribing wall with manned gates to collect taxes and protect residents.

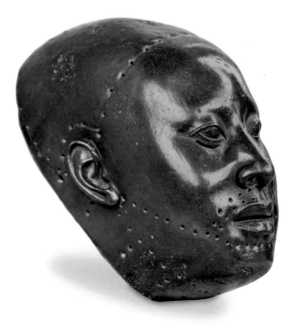

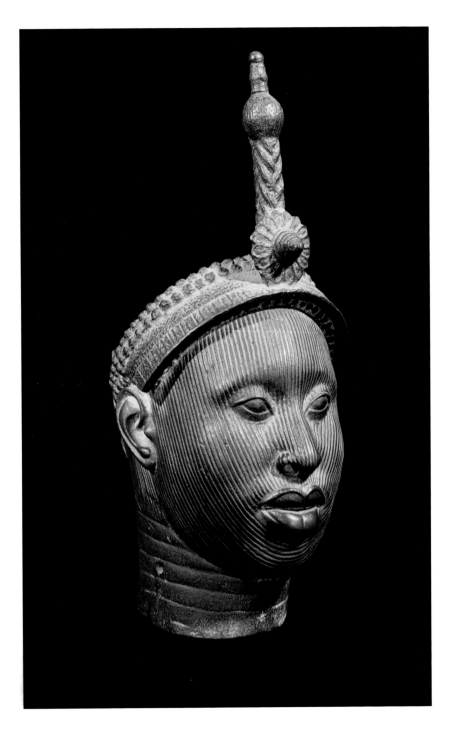

Ife bronze caster
Ife (Yoruba)
Olokun head
Nigeria, c.1300
Copper alloy, height
33.9 cm (13⅜ in.)
Nigerian National
Museum, Lagos

Olokun here is shown wearing an elaborate beaded crown, likely made from locally manufactured glass beads. The famous Ife dichroic beads change colour (from blue to green to yellow) in sunlight. This feature is linked to Olokun's increase and enhancement powers. Some of these beads complement Igbo Ukwu forms, and some were traded as far away as Timbuktu in Mali.

Obalufon II came from a dynasty whose origins trace back via local king lists to the 8th or 9th century CE. Under his patronage, artists created the larger corpus of stunning Ife bronzes and terracottas.

This Ife Obalufon mask is cast of nearly 100% pure copper, like roughly half the 16 life-size Ife metal heads he commissioned to honour important Ife Obas (chiefs). The Obalufon mask is without vertical line facial markings, in keeping with Ife's 2nd dynasty prohibition of this practice and in contrast to portrayals of 1st-dynasty Ife leaders that display vertical line facial marks. Yoruba trace their ancestry to the same Niger–Benue confluence area as the Igala and the vertical facial marks on some Igala masquerade forms reflect this. The copper Ife mask (devoid of facial markings) enabled a ruler to appear during ceremonial outings without identifying facial marks or other distinguishing facial features showing – emphasizing the office (rulership) over the individual (a specific ruler) in coronations and annual public rituals. Horizontal slits in the mask allowed wearers to see; holes at the top secured a royal beaded crown; holes around the mouth and chin affixed a symbolic beard (referencing male seniority and status). One Ife account suggests this mask so resembled the king that a palace chief used it to impersonate the ruler and extend his reign; when the act was revealed, both impersonator and artist lost their lives.

Decisions regarding art work styles carry consequences

One of the most remarkable Obalufon II commissions was a group of life-size and slightly smaller copper alloy heads, similar in style to his life-size mask. These memorialized powerful Ife chiefs under the Ooni's authority, along with other important leaders and deities. These heads, created as one grouping, evoke the two main royal dynastic lineages, past and present, one preceding Obalufon II and one he founded after returning from forced exile. One 1st dynasty-referencing Ife work, the Olokun head (opposite), embodies the deity of large water bodies (rivers, lakes and the ocean), wealth and increase. Oral accounts also identify Olokun as King Obalufon's finance minister. At the crown's front is a rosette-patterned medallion, which, like the incised vertical-line facial marks, identifies 1st-dynasty figures. The horizontal neck lines are beauty referents; lower neck holes secured this hollow head to a wooden or metal support post (for dressed display in ceremonies). This sculpture was long housed at Ife's Olokun shrine, near the

large pond where glass was smelted and where glass beads were offered to this god, encouraging children, plenty and other Olokun benefits. After the yearly rituals in which the work was polished then ceremonially featured, the Olokun head was again buried at the Olokun Grove. It probably remained within this context from the time of its creation until the early 20th century, when German ethnographer Leo Frobenius sought to acquire it. Following an Ife colonial-administered court ruling, the Olokun head remained in Nigeria, where it is housed in the National Museum today.

Obalufon II commissioned these arts after his return to power (following forced removal by a regional adversary named Oranmiyan arriving here by cavalry). During this second reign, Obalufon II created a new city plan and established new shrines honouring leaders of both sides, while fostering a new 2nd dynastic era linked with a mythical leader (now deity) Odudua. Obalufon II founded the elite Ogboni association (also called Osugbo in Ife and Ijebu) comprising distinguished elders charged with keeping roads safe and related jurisprudence (adjudicating and punishing various crimes). Ogboni also had roles in selecting new Yoruba kings from a group of qualified candidates. When needed, Ogboni had the power to remove a ruler from office. Ogboni membership badges comprise a sculptural pair (edan Ogboni) cast from copper alloys. Such figures are often joined at the top by a chain; attached iron spikes inserted into the ground enabled the sculptures to stand and draw power from Odudua (the Yoruba earth god and Ife's new 2nd-dynasty patron deity). This god is referenced in edan by the clay model that remains inside the work.

Ife, a rich agricultural centre, watered by springs encircling the city and run-off from surrounding hills, controlled a broad regional network of city-states from modern Nigeria to Togo, many, like Ife, distinguished by terracotta and stone pavements that recall medieval eastern Byzantine forms. In this golden era, Ife sculptural arts stand out in their idealized naturalism (perfection and relatively youthful features, conveying neither age, warts, nor wrinkles) and almond-shaped, kohl-enhanced eyes. The works' remarkable naturalism led Frobenius to promote his Ife Lost Atlantis theory in 1910, claiming the works were of ancient Greek manufacture. However, these remarkable sculptures are clearly of local Ife artistry and likely fashioned from local materials, even though contacts with the medieval Coptic–Nubian southern Nile area and the arrival of Nubian and Coptic era decorative arts possibly inspired other new Ife forms and styles such as ram's head pendants and prestige goods. Ife art style and technological skill remain peerless in any context.

Ife maintained close connections with the Niger River port and river crossing site of Tada, where several medieval Yoruba figures were found. The Tada sculptural grouping is closely linked to trade. The array of Tada cast copper and copper alloy sculptures includes several human figures (cover, page 25 and below), a baby elephant (evoking ivory trade), two ostriches (eggs, feathers – also suggesting international commerce), the earlier discussed robed priest-ruler, a standing Ogboni figure, a larger seated Ogboni sculpture (created by the same artists as the Ife Obalufon masks), and a smaller standing human with a ring-topped cane.

Maintaining the security of the Niger–Benue confluence area was critically important to area trade. In the Medieval period, the powerful Yoruba Ogboni association, centred in Ife, played a role in Tada, as evidenced by the mid-14th-century copper figure (below)

Yoruba Ogboni-linked bronze casting guild
Yoruba Ogboni figure enshrined at Tada, Nigeria, mid-14th century Copper cast, height 55 x 22 cm (21¾ x 8¾ in.) Nigerian National Museum, Lagos

Like this figure, some *edan* Ogboni sculptures may show the distinctive Ogboni membership gesture, with the left fist above the right. Works like this (called Onile) also marked the founding of new Yoruba centres and addressed the critical role Ogboni played in assuring safe passage, jurisprudence and local governance.

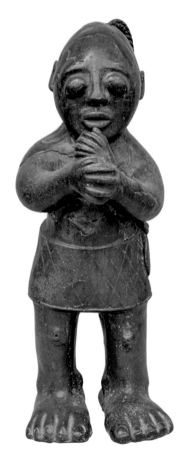

whose hand position references the traditional Ogboni gesture, the
left fist placed above the right. Reinforcing the figure's Ogboni- and
Obalufon-linked identity is its lost-wax copper form, a material not
seen in Yoruba divination and most other religious arts.

This large seated Tada shrine figure (see book cover) was regularly
carried to the river for ceremonies, washing, then polishing, leading
possibly to the loss of its forearms. These Tada sculptures were
believed locally to have arrived here via a legendary ancestor of
the Yoruba-linked Igala people named Tsoede. Though he lived
only later, ideas about a legendary early ruler are common in Africa.
Tada's medieval sculpture-rich shrine came under Nupe-linked
Kede control before British colonial takeover in the late 1800s.
Colonial administrators led efforts bringing historic area arts
(Tada, Igala, Ife, Igbo Ukwu and others) into museum settings.

MALI AND MOROCCO

The Empire of Mali was at its height in the Medieval golden era.
Ife's complement and main political competitor, it was ruled in the
early 14th century by Mansa Musa (r. c.1312–c.1337). In this area
we find stunning terracotta sculptures (opposite), many from the
inner Niger Delta area (near Djenne). The works date from the 11th
to the 17th century, but, sadly, unlike Ife and Igbo Ukwu, most were
sold from their original settings clandestinely without archaeological
site analysis that provides core context and meaning. One figure
excavated scientifically was in a residential niche, suggesting a
possible ritual function. These terracotta sculptures often portray
persons (male and female) in diverse poses – standing, seated,
hunched over or kneeling, either as solitary figures or pairs, often
in diverse attire – jewelry, loin cloths, distinctive coiffures. Most are
covered with a red slip prior to firing and some carry supplemental
modelled figures inside. In addition to denoting wealth and status,
equestrian figures also underscore cavalry's important role in
expanding Mali's state to cover a territory nearly two-thirds the
size of modern France. Mali also captured critical goods and enslaved
people, either to make the latter perform agricultural and military
work or to sell them to markets in North Africa and Europe. Other
terracotta sculptures from this region in the Medieval period often
feature male and female figures whose bodies are marked by disease-
like swellings associated with important area healing shrines, linked
either to indigenous or newer Islamic-linked medicinal practices.

While on pilgrimage to Mecca, Mansa Musa befriended a
Granada-born poet, al-Saheli (es-Saheli, c.1290–1346), who

Boso or Soninke ceramic artist
Equestrian figure
Djenne (Jenne) Inner
Niger Delta, Mali,
11th–14th century
Terracotta,
44 x 17 x 30 cm
(17⅜ x 6¾ x 11⅞ in.)
Nelson-Atkins Museum
of Art, Kansas City

This equestrian figure likely represents a ruler, chief or military leader. Horses also featured in enslavement exchanges, comparable to salt exchanges for gold.

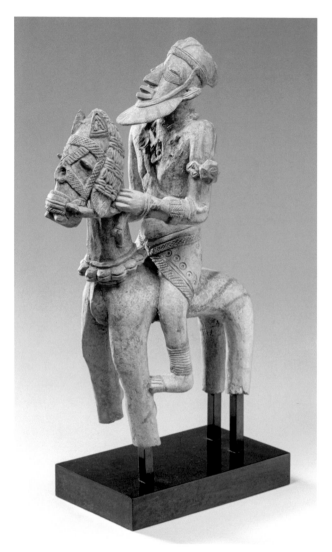

became his court architect, overseeing mosque construction at centres like Timbuktu and in Mali's royal capital. The latter conceivably was at Djenne – the commercial centre and home to many wealthy merchants. Djenne's island-like setting, enclosed much of the year by the Niger and Bani rivers, provided ample water to enable a dense urban population while safeguarding the city from attack. Contemporary descriptions of the Mali kingdom's capital identify it as an 'island' centre named Bny or Bani (alternatively

Byty or Bini/a), suggesting the Bani River locale. Mansa Musa's predecessor is said to have died while on a long-distance water voyage with a flotilla of boats and men crossing a wide sea *wadi* (stream) marked by a strong current. This was probably eastward along the Niger River towards the dangerous cataract-defined Niger–Benue confluence area of Tada, which the wealthy Ife controlled, rather than the Atlantic Ocean, as some scholars have claimed.

Djenne (Jenne), home to both the Soninke and Boso (Bozo) peoples, had long been an important commercial centre, and is among the oldest sub-Saharan urbanized centres, dating to 250 BCE and 1000 CE for the current town. In both Djenne and Timbuktu, genealogies remained important, whether found in elaborately recited oral traditions, on regularly repainted area building surfaces or in Timbuktu area manuscripts. Genealogy (and ancestors more generally) have significant roles in both Islamic and African traditions. Within Islam, it is often one's connection to Muhammed, his family or his earliest adherents – such ties being defined by a person's given names. Decorative arts of gold (including jewelry, horse regalia, dog collars and manuscript illuminations) were abundant in Mali in this period. They also remind us how critical Europe's move to the gold standard was, since much of this expensive mineral was traded north through the Mali Empire, making Mansa Musa the wealthiest person to have ever lived.

Boso architects/builders under French patronage
Great Mosque
Djenne, Mali, original
13th–14th century,
rebuilt early 20th century

The current mosque is a 1913 collaboration between colonial French administrators and local Boso architects/builders. The Djenne Great Mosque's somewhat straight-line plan suggests likely French influence, while the conical mound roof turret and other elements, such as its earthen construction, are local.

The Djenne Great Mosque (opposite) has a unique history. The building today replicates an original now-destroyed c.13th-century mosque. Both the Djenne and Timbuktu mosque exteriors reflect local area architectural forms. The original medieval Djenne mosque structure may have been commissioned by Mansa Musa, overseen by his Granada-born architect, al-Saheli, who also designed the still extant Djinguereber Mosque in Timbuktu. Roman-style stone arches mark the medieval Djinguereber Timbuktu mosque interior. al-Saheli also designed the Mali emperor's c.1328–30 palace – now lost, but described as featuring a large dome with 'coloured patterned' arches and gilded walls. The palace dome's structure and shape likely resembled later Hausa area rib-vaulted domes and complementary Andalusian examples. Both appear to be based on nomadic African ribbed vaulting techniques. A royal retreat with a domed roof of similar ribbed vaulted design was in Granada during al-Saheli's youth and complements the earlier African-influenced Cordoba domed mosque.

Thanks to Mansa Musa and his successors, Timbuktu became a major university centre. Among the goods the emperor brought back from the Hajj were books and teachers – Prophet Muhammed's descendants, whom he met in Mecca. Timbuktu soon became significant for book making, calligraphy and illumination arts. In Islamic Maliki law, which dominates here, the focus is on the ancestral origins in addressing healing, law and other concerns. Local Mali and other African divination forms similarly seek answers from ancestors, deities and/or local spirits.

The need to rebuild Djenne's mosque reflects later history, when 19th-century Fulbe/Fulani leaders following stricter tenets of the revolutionary leader and Gobia (Hausa) Fulani cleric Usman dan Fodio (r.1804–1817), blocked the Djenne mosque's roof drainage pipes, and adjacent earthen walls melted into a massive mud pile. In 1907, after French colonials defeated the Fulani, they had the mosque rebuilt. At the same time, colonial governments passed laws breaking up the economic structure of pastoral trading groups leading to resentment and poverty.

The earlier Medieval period's artistic creativity developed partly in response to Mali state expansion and enslavement practices as individuals fled to more remote protected areas to maintain their freedom and create their lives anew. One such site was Mali's isolated Bandiagara cliff area, where the Tellem once resided, and which today is home to Dogon populations. The cliffs above these mountain villages offered safety for granaries (secure from theft),

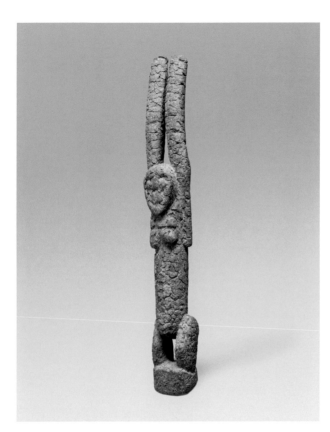

Tellem wood carver
Tellem figure
Bandiagara cliffs, Mali,
11th–16th century
Wood and
organic materials,
49.2 x 6.7 x 6.9 cm
(19⅜ x 2⅝ x 2¾ in.)
Art Institute of Chicago

**The abstracted simplified
forms and raised arms of
Tellem figures served as
models for later Dogon
artists. These sculptures
are often associated
with family and clan
ancestors and secured
in caves above the village.
They are brought out
for annual harvest rituals
and other occasions.**

burials and storage for historic masks and figures (above). The
sculpture's raised arms are seen in later Dogon communities as
a prayer gesture to the ancestors and high god Amma for rain,
while also invoking mythical Nommo – the first earthly beings,
quasi human-fish, who descended from the sky, referencing
creation and world order. Similar gestures distinguish Dogon
stools, Kanaga masks and often doors.

Like Mali, medieval Morocco witnessed unique artistic
florescence and celebrated university and manuscript illumination
centres. The first world university was founded in Fez, in 859,
when a woman, Fatima al-Fihri, established the mosque that later
transformed into the famous al-Qarawiyyin university. Fez became
the Marinid dynastic capital controlling much of Morocco, Algeria,
Tunisia and southern Spain (Andalusia) in the Medieval period.
Marinid Sultan Abu Ya'qub Yusuf (r.1286–1307) commissioned
an extraordinarily beautiful Qur'an in 1306 (opposite). Islam was

fundamentally shaped in Africa, both in the early years after Muhammed's death and over subsequent centuries. West Africa and Andalusia share a distinctive calligraphic form. Arabic here not only has pronunciation differences (emphatic consonants, sound simplification) but also local loan words from the Amazigh.

This Moroccan Qur'an (below), which is considered by experts to be the finest example anywhere, includes the Sura al-Fatiha or opening Qur'an chapter written on parchment on a well-designed seven-line page, with wide plain margins, harmonically balancing text areas and decorative motifs. Gilt circles delimit verses; the other richly coloured elements here (as elsewhere) mark vocalizations. The sura (chapter) heading is in gold, with elements inserted into a decorative panel enhanced by delicate arabesques, palmette elements and parallel linear forms. The text reads: 'In the Name of God, the Most Compassionate, the Most Merciful / Praise be to God, Lord of the two worlds / The Most Compassionate, the Most Merciful / Master of the Day of Judgement / You [alone] we

Marinid calligraphic artist
Qur'an page
For sovereign Abu
Ya'qub Yusuf
Marinid dynasty,
Morocco, 1306
Bavarian State Library

Magrebi (North African) script, like Andalusian script, includes more rounded letters and extended horizontal flourishes, with open curves often dipping below the line. Like other Arabic scripts this example is written and read from right to left, incorporating foliate and/ or floral design elements, and is punctuated with various coloured inks – red, blue and gilt.

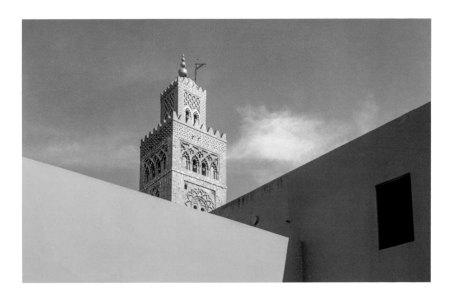

worship...' The original leather binding, which is equally stunning,
is enhanced with a gilded star pattern and incorporates a *waaf* mark
indicating the work was a later gift to the Great Mosque at Tunis;
it was taken during Charles V's 1535 sack of Tunis after which
a German humanist acquired it.

During this period, the Kutubiyya Mosque in Marrakech
(above) was built. It displays distinctive monumentality and beauty.
This mosque was founded in 1147 soon after the Amazigh Almohad
caliph Abd al-Mumin had conquered the city (founded by the
Amazigh in 1070 as their capital). It was wrested from less strict
Almoravid Amazigh Muslims (whom they labelled heretics), with
rebuilding beginning in 1158, and the minaret finished in 1195. This
mosque and minaret, which still stand as masterpieces of Moroccan
design, are a source for structures in both Seville (the Giralda)
and Rabat (Hassan Tower), as well as later Moroccan–Andalusian
'brick enhancement' *sebka* style decorations, revealing the ongoing
Amazigh importance in monumental architecture and other arts.
While this edifice is stone, the immense gated rectilinear walls
enclosing the city are made of earth. The name for this mosque,
Kutubiyya, references the Arabic word for booksellers, conveying
the primacy of book arts available in the nearby *souks*. The mosque's
qibla wall orientation conforms with the earlier Fez and Cordoba
mosques. Not far away is the tomb of the 17th-century female
mystic Lalla Zohra (also known as Fatima Zohra bint al-Kush),
highlighting her importance to religious and university history.

Marrakech architect
Kutubiyya Mosque
minaret and exterior walls
Marrakech, Morocco,
1195

**The balls atop the
minaret were likely
gold, consistent with
gold's importance in
this centre through the
trans-Saharan trade.
Located a few hundred
metres from the mosque
is Marrakech's historic
souk (marketplace);
nearby (and accessible
to the mosque) stood
the palace, reflecting
co-joined religious and
political power.**

EASTERN, SOUTHERN AND CENTRAL AFRICA

Elsewhere in Africa, the Medieval golden age arts were also enhanced by gold – as in the lively Mapungubwe gold rhinoceros from South Africa (below) dated c.1000 to 1300. The work's core is carved wood affixed with thinly hammered gold sheets, an assemblage technique of applying expensive metals also seen in the Asante and Dahomey kingdoms. This wonderful hand-size sculpture conveys African artists' extraordinary observational skills. Mapungubwe was a wealthy trading centre and class-defined society in which the wealthy lived separately on a Limpopo Valley area hilltop site. This is where their palace once stood on land resurfaced by hauling up some 2,000 tons of soil from below. The rhinoceros was found in a tomb. Elite burials often included gold and copper ornaments and glass beads. The first state in southern Africa, Mapungubwe was a complex society. Residents owned cattle, sheep and goats, but also undertook extensive farming (millet, sorghum and cotton) in the fine local soil, enriched by annual flooding. Cereals were stored in granaries, furnishing food for this growing population throughout the year. They also hunted and gathered wild foods, during which they came across animals such as jackals, from which Mapungubwe's name originates ('Hill of jackals'). Ostrich shells

Mapungubwe artist
Mapungubwe golden rhinoceros
South Africa, 1075–1220
Wood and gold,
14.5 x 5.5 cm
(5¾ x 2¼ in.)
Mapungubwe Collection, University of Pretoria Museum, South Africa

The artistic assemblage technique allows effective and efficient use of rare, soft materials like gold. The details – ears, eyes, horn, tail and feet – are striking, as is the rendering of musculature and weight.

fashioned into beads complement earlier Blombos Cave forms. Mapungubwe political authorities helped to maintain and manage economic interests, not only smelting and trading gold, but also controlling the trading of other goods (ivory, salt, shellfish, iron artefacts) along the Limpopo River into central Africa and Egypt, as well as across the Indian Ocean to Arabia, India and China. In the 1400s the Mapungubwe population left, and the area's political centre shifted to the site known today as Great Zimbabwe.

The important medieval centre of Great Zimbabwe (opposite) is situated about 400 km (250 miles) away near Lake Mutirikwi and near once gold mine-rich plains between the Limpopo and Zambezi rivers. This centre, like Mapungubwe, was settled by Gokomere (ancestors of the Shona people, who are still prominent in this southern African region). The city that emerged here spans some 7.22 square kilometres (2.79 square miles). The name Great Zimbabwe derived either from the local Shona dialect word *dzimba-hwe* (meaning 'venerated houses' and often meaning chiefs' homes or graves) or *dzimba-dza-mabwe* (meaning 'large stone houses'). A European description likely of this centre in the early 1500s reveals that it was then guarded by a 'nobleman' who bore the title Symbacay.

Great Zimbabwe is the largest of over 150 stone wall-demarked sites (part of a larger Zimbabwe kingdom, today called 'zimbabwes') extending from modern Zimbabwe to Mozambique. All are constructed of stone schist blocks without mortar – structures that were interspersed with additional earthen and earthen-brick habitation buildings (*daga*). The Great Enclosure integrates the site's massive boulders into a striking built environment defined by an 11 m (36 ft) tall ovoid-shaped wall, with a shorter 10 m (33 ft) ovoid wall positioned concentrically within it and a narrow passageway conjoining the two that leads to a 9 m (30 ft) tall, 5.5 m (18 ft) wide stone flat-topped conical form. Some label this a symbolic granary perhaps serving as a ritual or oratory platform connected to religious or political elites. A spring at the site may have had oracular functions. Perched atop monoliths in the Eastern Hill complex enclosure were eight stone birds which may have symbolized lightning and cosmological forces – a factor also suggested in the horizontal zigzagging lines distinguishing some Great Zimbabwe stone walls.

Artefacts and scientific dating support a 5th-century initial Great Zimbabwe settlement and continuous habitation from the 12th to the 15th centuries. Most finds date to the latter century, dates that complement the presence of Persian, Syrian and Chinese materials in the region. Great Zimbabwe had a strong economy.

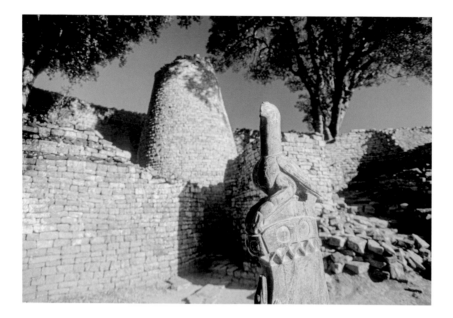

Shona architects
Great Zimbabwe
Zimbabwe, 11th–15th
centuries

**Great Zimbabwe
is defined by three
occupancy sites: the Hill
section (the 'Acropolis' –
the oldest section, built
c.900, and one-time
religious centre); the
Valley ruins; and the
Great Enclosure.**

It was the centre not only of rich agriculture, but also of cattle herding (cows likely owned by elites and moved seasonally for pastorage) and hunting (elephants and other game) as well as copper, iron and gold mining and long-distance trade. Jewelry (pendants, bracelets and beads), works of ivory, tools and weapons of iron, copper and bronze, imported coins from Arabia, porcelain, a Ptolemaic-era (c.323–30 BCE) *ushabti* figure from Nubia or Egypt (forms also circulating to West Africa in this era) and glass from Persia and China – the latter helping to date the site – were all found at Great Zimbabwe. Whatever the cause of the site's termination – political instability, environment changes (water shortage, famine) or diminishing gold mine returns – Zimbabwe, though declining around 1450, was still sporadically occupied into the early 16th century, by which time many stone-working and ceramics traditions had shifted to sites further south. When it was 're-discovered' in the 19th century by Cecil John Rhodes and other colonizers, the architecture's construction was falsely credited to outsiders and mythic figures like King Solomon and the Queen of Sheba, pejoratively suggesting that Black Africans did not possess the technological skill.

Medieval impacts extended to the coast, where Islam also had a foothold and critical role in international trade, and where important architectural monuments were also erected, in this case, largely in a local material closely resembling stone – entirely built in coral.

On the East African coastal island of Kilwa Kisiwani in modern-day Tanzania (above) we find one such example. Founded by Mwera travellers arriving from the African continent in the 8th century CE, Kilwa became a thriving Swahili centre (from Kiswahili, the regional Bantu–Arabic-linked trade language). Kilwa was a sultanate, founded by a local woman and a Persian king's son according to oral tradition. At its 13th- to 15th-century height, Kilwa was a trading force connecting East Africa, the Arabic peninsula, India and China. Its commercial sphere also included island cultures such as Zanzibar, Comoro and Madagascar, as well as inland African centres – Zimbabwe and others. Imports included luxury foreign textiles and ceramics; exports included gold, ivory, tortoise shell, spices, tree gums, coconut oil and people. The elegant, imported ceramics from the Arabic peninsula and China were displayed in elite homes' interior wall niches all along the Swahili Coast. Between 1100 and 1600, Kilwa minted its own coins; some were recovered inland at Great Zimbabwe, another reached Australia. Cotton was grown here as well, evidenced by 12th-century spindle whorls – important for both cloth and boat sail manufacturing. The sea furnished much of the food, which was cooked in locally made vessels.

Kilwa was described in 1331 by Moroccan visitor Ibn Battuta as one of the world's most beautiful cities, replete with mosques,

Mwera architect
Kilwa Great Mosque
Kilwa Island, Tanzania,
10th–13th century

The early 14th-century ruler Sultan al-Hasan ibn Sulaiman extended Kilwa Great Mosque and commissioned a two-acre palace, called Husuni Kubwa ('Great Palace'), complete with a dome, reception hall, commercial court and multiple 3 m (10 ft) tall rooms. A coral causeway and breakwater structures were also built, adding protection from the sea.

fortifications, a palace, homes and cemeteries. The site was also one of many early slavery-linked African centres (page 104). On Kilwa, elite coral and stone buildings replaced earlier structures of woven upright and horizontal poles packed with earth. Only the wealthy had indoor plumbing. Kilwa Great Mosque was founded as a congregational mosque in the 10th century but construction took place in several stages over the 12th and 13th centuries – making it one of the earliest such structures still surviving on the coast. Sixteen bays delimited by nine pillars (originally coral, later wood) define the interior.

Christianity continued to play a key role in East Africa in this era. Lalibela, the site of the Church of St George (Bete Giyorgis), the largest stone-cut monolithic church ever built, dates to this Medieval period. Lalibela's hard volcanic edifice speaks to East Africa's interest in greater architectural monumentality and permanence. In Ethiopia eleven churches carved from living rock bear witness to this legacy. The Church of St George (below) is one such structure, created by devotees of Christian King Lalibela (1162–1221) from the powerful Zagwe dynasty. The site replaced Jerusalem as a pilgrimage centre in the 13th century after Holy Land travel became unfeasible due to Muslim coastal impact.

Ethiopian architect
Church of St George
(Bete Giyorgis)
Lalibela, Ethiopia, late
12th or early 13th century

This church incorporates key design features from Axumite stone stele and edifices, particularly the chiselled raised square window and door frames. Brightly hued, richly painted interiors feature murals of Christian subjects along with architectural detailing – windows, doors and pilasters.

-

Local traditions maintain that the Church of St George was carved by supernatural means, specifically angels

-

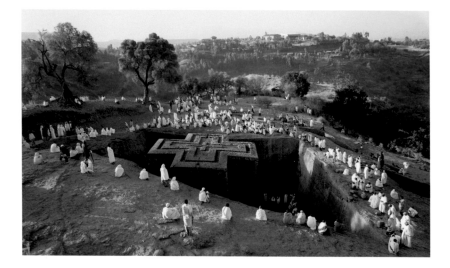

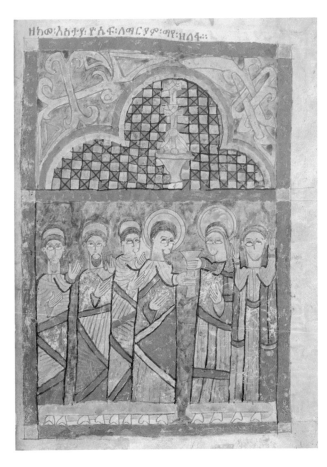

**Amheric manuscript
illustrator**
Zir Ganela Gospels
(MS M.828)
Virgin Mary 'Testing
with Water'
Ethiopia, 1400–1
Illuminated manuscript,
vellum and ink
Morgan Library &
Museum, New York

**Ethiopian Gospels are
among the most holy
texts and are of stunning
beauty. These are written
on specially prepared
vellum and inscribed
in the local Ge'ez
(Ethiopian) language, not
Greek (the Alexandrian
Church language),
suggesting that the
audience was local. These
manuscripts often were
commissioned by people
of wealth, then gifted
to the Church.**

Most early African Coptic churches, the earliest being 337,
followed models of Roman basilicas. Over time, Byzantines built
churches with cross-form interiors within a rectilinear shape (Hagia
Sophia, for example). Lalibela includes window and portal details and
other building features complementing earlier pre-Christian area
Aksum forms. Lalibela's exterior cruciform plan shares parallels with
Byzantine church principles including Jerusalem's Church of the
Holy Sepulchre (the traditonal site of Jesus's crucifixion and burial),
with its head, two arms (transept), and feet (ambulatory). Lalibela
area churches comprise two groupings separated by a stream –
named the River Jordan, after the river in which Christ was baptized.
Adjacent two-storey villager homes were similarly constructed of
stone – here, stone blocks. Modelled in some ways after Jerusalem,
Lalibela has remained a major Christian pilgrimage site.

At Lalibela and in other early Ethiopian Christian centres, richly illuminated manuscripts became important arts. The Garima Gospels date to c.500 CE and are the earliest surviving complete Christian illuminated manuscripts in the world. The Holy Family, some believe, were once in Egypt, so Africa holds special importance in local Christian imagery. The work shown here (opposite) is a page from the Zir Ganela Gospels (1400–1) depicting the Virgin Mary and an apocryphal scene that appeared prominently in Ethiopian contexts, that of Mary Testing the Water. She and the others are shown in bright green, red, blue and yellow hues, with white and black detailing. The text is in the local Ge'ez language. The importance of women in Ethiopian nativity and related scenes is notable. For example, Salome, the midwife, is often shown reaching both hands towards Mary following delivery. Salome is mentioned in many Ethiopian writings such as the History of Mary, she is also depicted in paintings and icons. Here Mary is being given a goblet of 'bitter water', a test or oath-linked trial believed to determine adultery, to assure she was indeed pure. Many in the scene look up towards Heaven in anticipation of the answer.

In the early 7th century, Byzantium lost Egypt to Persia, and in 641 CE, Coptic forces were replaced by Muslims. In the Coptic Christian area in the southern Nile region, Meroë remained Nubia's capital from c.330 BCE. In this broader area three medieval Christian Nubian kingdoms emerged: Nobatia (with its capital at Faras in today's Sudan), Makuria (at Dongola) and Alodia (also called Alwa, its capital at Soba, now Khartoum). These Nile Valley Coptic centres extended from the first cataract to modern Khartoum (Sudan). This broader southern Nubian area witnessed relative peace from the mid-7th century on, enabling Nubian Christian and other arts to flourish, drawing on the legacy of earlier Meroitic traditions. Here an estimated fifty churches and elite residences created rich wall paintings, ceramics, textile arts and metalwork. Faras, the bishop's seat with its cathedral and multiple churches, was especially important. Medieval Christianity remained prominent here through c.1323 CE but continued to some extent through the 15th and 16th centuries and into the present. Following the 641 CE Muslim takeover of the northern Nile region, these kingdoms were largely cut off from the rest of the Christian world, but continued to thrive and grow, not only displaying an extraordinary richness of art, culture and religious life, but also at times posing a threat to the north. In the 7th century, after Nubian Kush's fall, Makuria united with Nobadia and annexed the other provinces, including Faras.

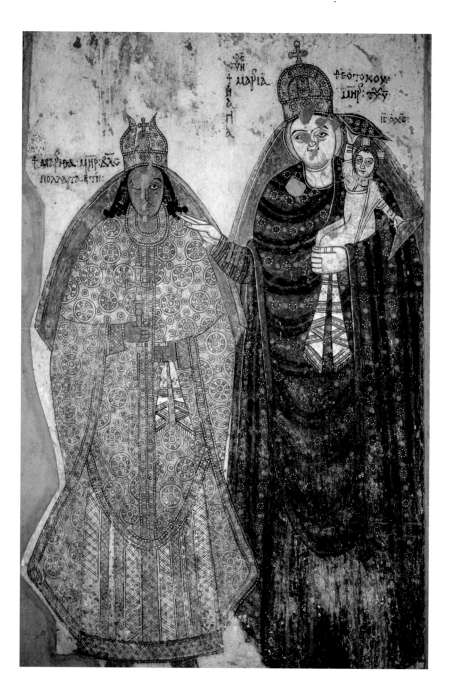

Faras mural painter
Queen Mother Martha
protected by the Virgin
holding Jesus
Faras, Sudan, 11th century
Mural painting

**Christian Nubia engaged
with earlier Pharaonic
traditions as part of their
symbols of authority,
while also drawing on
motifs from the broader
Byzantine Christian
world. The Queen
Mother's crown shows
small upward-curving
ram horns like ancient
Nubian Kushite crowns
and contemporary
Banganarti priest-leader
crowns. Between the
horns, a circular motif
references the sun,
an important
Nubian symbol.**

Nubian Christianity and art followed a somewhat different track from other medieval Christian centres, especially once regular engagement with Alexandria and Jerusalem was foreclosed. In this period in Nubia, Egyptian and Sudanese Christians began speaking and writing in the new lingua franca, Arabic, but their liturgical language remained Coptic (a unique Greco-hieroglyphic script with twenty-four Greek signs and seven from Old-Egyptian Demotic). Reflecting Nubian religious adaptability and creativity, many Coptic written texts include Christian, Manichaean and Gnostic materials, although biblical writings predominate. Armenian Christianity remains the closest complement to the Coptic faith and art.

In Nubia, both Christian and political engagements sometimes reflect earlier Pharaonic beliefs and practices. Even today, Copts follow the Pharaonic religious calendar and maintain dietary strictures (including fasting) and their own magic papyri traditions. They converted the *ankh*, the Pharaonic life and eternity sign, into a Christian symbol of the hereafter. As with Pharaonic rituals, holy water was used during ceremonies and carried in small round bottles. Monasticism (which spread west from Egypt), pilgrimages and books relating to Saints' Lives (including Saint Menas) are important. Coptic imagery features outward-staring eyes that engage the viewer directly. Decorative forms include bright geometric patterning and various plant motifs (vines, trees, grapes) and Greco-Roman derived mythic figures (sirens, Gorgons). From the 13th century onward, local dynastic disputes, increasing pressure from Egypt, and advances from the Funj kingdom further south brought a decline to dynastic-supported Christian worship, although in local homes and communities it continued.

The picture opposite shows an 11th-century mural from Faras Cathedral with, on the left, Faras's Queen Mother (*nonnen*) Martha and, on the right, her two protectors: Mary and Jesus. The Queen Mother wears an elaborate robe with bejewelled medallion forms, consistent with Nubia's international trade role and access to expensive brocades and silks. Mary's more sombre robe evokes her seniority and religious status. Jesus wears white and has an adult physiognomy complementing Mary's. The Queen Mother's left hand touches a decorated cloth, possibly indicating the holy veil (worn by Mary while giving birth, a tradition important here). The gold in her crown and gown reflects Nubia's long gold-mining legacy. In Jesus's right, skyward-reaching hand, he holds a lozenge-shaped cross (common in early Byzantine art), its four corners perhaps delimiting the four elements, or the universe's creation (per Genesis). In his left hand, he holds a triangular form, suggesting the Holy Trinity.

Queen Mother Martha's portrait on the wall of Faras Cathedral reinforces her piety. On a nearby wall is a Nativity scene showing Mary's regal status as mother of Jesus. Linking the Queen Mother to Mary reinforces the divine sanctioning of both the ruler and his mother and the importance of African queen mothers in general. Nubian society was matrilineal, with rulers tracing their lineage through their mother's brother. In royal lists, queen mothers' names often directly follow the kings' names. These women and others enjoyed high status in related arts. Like many other African queen mothers, Martha helped advance her own son to become ruler. Her son, King Raphael (ruling c.1002), oversaw the construction of a large multi-domed red-brick palace in Old Dongola's capital, distinguished by wide streets, large homes, a circumscribing city wall and many churches. This remarkable Nubian Christian culture ended after the 1315 installation of a Muslim puppet king by the Mamluk Cairo Sultan at Old Dongola. During a time of a heavy drought, warriors from the nomadic Juhayna Arabic peninsula attacked this Nubian area. Some Christians converted; others fled, some of whom plausibly reached the Lake Chad area and West Africa.

In southern Africa, dating to near the beginning of the Medieval era, is a corpus of engaging ceramic heads (opposite). These works were fashioned around 500 CE and include seven heads uncovered in Lydenburg in the eastern Transvaal area, some of the oldest known Iron Age sculptures below the equator. Smaller heads here portray animal imagery, one with a long snout, another possibly with a lion's mane. How these sculptures were used is unknown, although surface holes suggest they were worn in ceremonies – possibly initiations. As with the medieval Yoruba Olokun head at Ife, these sculptures were considered important enough to have been buried and unearthed for later related events. The Lydenburg heads show how much Africans cared for their arts, preserving them centuries after their original use. They also demonstrate how important art works are to reframing the histories of areas that once were assumed to be 'empty' and appropriate for European taking. Near the end of the Medieval period, in Central Africa, the Kongo kingdom emerged, having been founded around 1390 through a political marriage between Nima a Nzima (of Mpemba Kasi) and Luqueni Luansanze (of the Mbata), the latter choosing to build the kingdom's new capital at Mbanza Kongo in modern-day Angola to the south. Pottery traditions across the Mbata province speak to the Kongo's cultural and socio-political breadth.

Sotho ceramic artist
Lydenburg head or
helmet mask
South Africa, 500 CE
Fired clay, height
38.1 cm (15 in.)
Iziko South African
Museum, Cape Town

**Asymmetrical linear
facial marks and
horizontal neck rings
distinguish some of
these works and suggest
complements (if not
specific historical
connections) with
later African art
traditions elsewhere.**

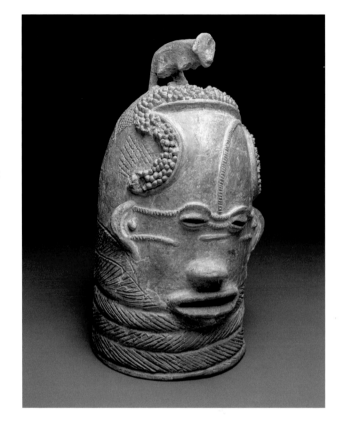

KEY IDEAS

During the Medieval era, Africa was in many ways a global
trading centre.

New technologies and widespread trade enabled more populous
urban centres to develop, giving rise to specialized artist groups
and new materials.

Global religions – including Christianity and Islam – continue to be
shaped within Africa.

Trade connections within and outside the continent brought new
goods, technologies and ideas.

KEY QUESTION

What is the aftermath of the Black Death for Africa as European
needs for labour rise?

EARLY MODERN TRANSFORMATIONS (1450–1849 CE)

-

The elephant never gets tired of carrying its tusks

-

Liberian proverb

Portuguese ships reached the West African area of the Gold Coast (now modern Ghana) by the 1470s and the kingdoms of Benin and the Kongo (Congo) by the 1480s. These navigators were searching not only for a way to access Gold Coast gold sources but also Asia and its rich array of expensive spices without having to go through Muslim intermediaries who controlled existing trade routes, limiting access and profits. In 1494, the Treaty of Tordesillas divided the two main non-European worlds between the era's two naval superpowers: Spain (receiving the Americas) and Portugal (Africa and Asia). Pope Julius II sanctioned the Treaty in 1506. Advancing missionary activities in these arenas were co-joined from the outset with trade interests, diplomatic engagement and the acquisition of enslaved peoples. Large ocean-going sailing vessels, more sophisticated navigational instruments and the new availability of firearms were crucial to transforming earlier enslavement practices in many countries into one marked by far more violence, death and trans-generational strictures. Even prior to this event, Africa was undergoing internal changes as residents emerged from the devastating Black Death, so related military actions left a greater impact. Another change transpired in 1492, the year Columbus reached the Americas, but equally importantly for Africa, the fall of Muslim-led Amazigh-aligned Granada to Christians, forcing out residents (many settling in Morocco and Mauritania) and leaving Africa without a secure European foothold.

KONGO, SIERRA LEONE AND BENIN

Kongo Kingdom (today spanning the Democratic Republic of Congo, the Congo Republic and Angola) saw major transformations in the Early Modern period. In 1482–3, the Portuguese explorer Diogo Cão reached the Congo River's mouth. The first European to engage with Kongo leaders, he established a relationship of mutual interest that brought Christianity to then King Nzinga-a-Nkuwu whose baptized name was João I. Under his reign, and that of his successors, many local nobles converted. In the initial 1483 visit, the Portuguese left several missionaries in Kongo and took several Congolese back to Lisbon. The latter individuals were both taught Portuguese and converted to Christianity prior to being returned to Kongo in 1485. More missions followed, but it was especially Afonso I of Kongo (c.1456–1542/3) who is credited with broader Christian conversion efforts. He banned the worship of local deities, labelled their related sculptures as 'idols' and demolished local religious shrines in Kongo's capital. Part of this engagement had a deeply problematic

Kongo bronze caster
Sculpture of
St Anthony of Padua
Kongo, Democratic
Republic of Congo,
16th–19th century
Bronze,
10.2 x 3.5 x 2.9 cm
(4 x 1⅜ x 1⅛ in.)
Metropolitan Museum
of Art, New York

**In his left hand, Jesus
holds a cross-topped
globe – a symbol of
Christian authority
first introduced in the
Middle Ages. He points
his right hand towards
St Anthony's chest, as
if to bless him. Both stare
outwards directly at the
viewer, as if to call us
to worship.**

underside, for the Portuguese began to promote enslavement as part
of missionary and trade activities. Here, and in many other African
areas, this pact of violence between Christian missionary activities and
enslavement was perpetuated with falsehoods that Africans lacked
viable local religions – and civilization more generally. African art
works from this era, however, reveal the enduring vibrancy of African
cultures, beliefs and arts.

Some art works commissioned in this period of missionary activity
and subsequent centuries speak to how Christianity was framed within
the local Kongo cultural and aesthetic canon. The picture above
shows a Kongo depiction of St Anthony of Padua. This sculpture

was probably created during the reign of King Nzinga-a-Nkuwu, who ruled as the fifth ManiKongo (Kongo King) between 1470 and 1509, or his successor Mvemba a Nzinga (Afonso I). St Anthony, a Portuguese-born Franciscan friar, died in Padua, Italy, in 1231 and was canonized soon after, remaining important in the Franciscan and subsequent Capuchin orders that undertook missionary activities in Kongo and Africa more generally in the Early Modern period to today. The Kongo artist has engaged the saint's well-known iconography; although he is usually shown holding the infant Jesus in one arm, it is the adult Jesus that we encounter in this work, balancing effortlessly on St Anthony's open hand. With equal ease, St Anthony balances a heavy metal cross in his right hand, foreshadowing Jesus's crucifixion. Both Anthony and Jesus wear similar cloth wrappers, the former's reaching his ankles, as befits a Kongo adult. St Anthony also wears a cord knotted at the waist, tassels extending down the front – the three knots on the friar's cord represent his vows of poverty, chastity, and obedience.

Further inland, in the agriculturally rich interior grassy savanna area, the Kuba political dynasty arose in the early 17th century when the Kongo kingdom was declining. Royal myths tell of Kuba's first king, Shyaam aMbul aNgoong (Shyaam the Great), travelling to other area kingdoms (including Kongo) and from that experience founding his own. Similar royal legitimacy myths, framed around the relationship of new kingdoms and earlier precedents, are common in Africa and help concretize an emerging power's political footing. Kuba royals created new art forms that drew on elements from Kongo and other cultures but were very much their own invention. The Kuba *ndop* sculpture that portrays Shyaam himself was created c.1625 and depicts him with his reign symbol (*ibol*), the well-known African game of *lele* (or *mankala*). This and other wooden *ndop* carvings (opposite) show the king sitting cross-legged upon a square plinth that Kuba rulers used in public meetings, comparable to Kongo royal seating traditions. Similar *ndop* forms were created for successive Kuba rulers, often as a sculptural grouping long after their deaths, to recall each reign. *Ndop* figures served as royal stand-ins when the king was away and were cared for by his widows after his death. As death neared, the figure was brought close by as receptacle for his spirit and to bring benefits such as fertility and well-being to his successor and the population at large. A cowrie shell band encircles the waist (currency linked to Indian Ocean trade, also used regionally and in West Africa). The unusual *ndop* hoe-shaped headdress, worn blade forward, highlights agriculture's newfound importance to the local economy. In this competitive setting, titled members battled with one another

to create innovative design patterns; these forms decorated clothing, prestige objects and palace walls. At his enthronement, each king was required to select a new capital site (often in vicinity of an earlier ancestral one), unifying the population to build a new palace centre where recently created designs were prominently displayed.

Trade goods sent from Africa to Europe through oceanic routes during this period included rare, highly valued materials such as ivory, which had been heavily traded from the continent in the Middle Ages. In this era, European patrons were not only interested in raw ivory to be fashioned by artists at home, but sought out skilled ivory carvers in Africa itself. In the late 15th through 16th centuries, elegant ivory containers fashioned by Sapi artists in what would become Sierra Leone reached European patrons. Ivory salt containers (cellars) were based on Western forms but included several local African design elements, animals and stylistic innovations. This salt cellar (overleaf)

Kuba wood carver
Kuba *ndop* figure depicting one of Shyaam's successors, Nyim Mbo Mboosh (r. c.1650–1700), Nyim Mish miShaang maMbul (r. c.1710), or Nyim Kot aNee (r. c.1740)
Democratic Republic of Congo, 17th–18th century
Wood,
49.5 x 20.3 x 25.4 cm
(19½ x 8 x 10 in.)
Brooklyn Museum, New York

This king's *ibol* (icon) takes the form of a drum. The cowries on the belt and armbands symbolize Woot, the first human and bearer of civilization. On the king's left hip he holds a ceremonial sword. Noteworthy here and on other Kuba *ndop* figures is the extraordinary sense of calm.

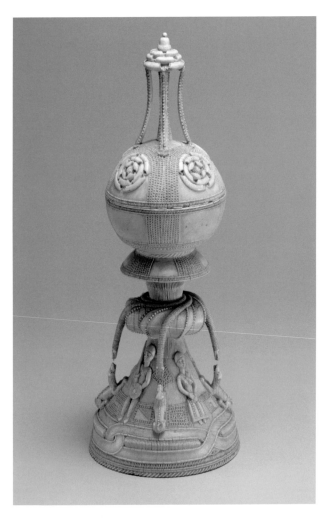

Sapi ivory carver
Sapi lidded salt cellar
Sierra Leone, late 15th–
early 16th century
Ivory, 29.8 x 10.8 cm
(11¾ x 4¼ in.)
Metropolitan Museum
of Art, New York

**Snakes slither down
from the vessel's centre,
their arching necks,
heads and tongues
extended towards the
muzzles of crouched,
sniffing dogs with raised
hackles, revealing fear.
In between are alternating
shield-bearing and
weapon-carrying men
and bejewelled women
in beautiful textile
wrappers, the patterning
complementing this
overall linear framing
pattern.**

features a globe-shaped vessel surmounted by an elegantly arched
'crown', incorporating on the cap what appear to be long bead strands,
like those featured in Euro–African trade during this and later eras.

What are these serpents (and concerned dogs), whose presence
is notably different from what would be seen on European-carved
salt cellars from this era, including those serving as models? Most
likely the snakes symbolize local water spirits (Niiganne; Ninkinanka)
affiliated with powerful spirits and individuals believed to aid one in
acquiring riches and other desirable goods (iron, gold, clothing).
Yet these mystical water spirits are also potentially dangerous, linked
to sorcery-like rituals (such as offering a life for material benefits).

Benin Igbesanmwan carving guild member
Pendant mask identified with Queen Idia, mother of King Esigie
Benin (Nigeria),
early 16th century
Ivory and iron,
23.8 x 12.7 x 6.4 cm
(9⅜ x 5 x 2½ in.)
Metropolitan Museum of Art, New York

On the mask's crown are faces of Portuguese men (with long, thin noses and straight, outward-flaring hair) alternating with mudfish (African lungfish), whose curving bodies and long gills complement Portuguese coiffures. Because the deceased are linked to bringing wealth and danger, and are believed to travel by sea to ancestor lands, the portrayal of ancestors and the Portuguese shared key components.

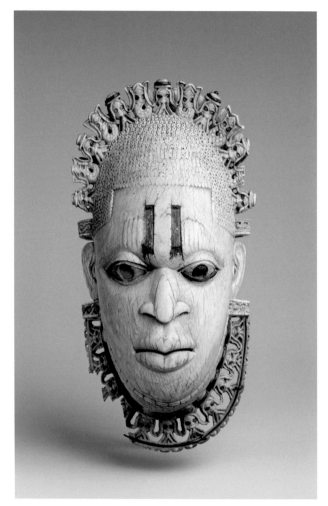

In many ways, Europeans here were credited with similar mystical powers, as rich seafarers from a distant land (which they shared with the dead in local beliefs) potentially bringing both death and wealth. The dogs, their hackles raised in nervous anticipation, seem cognizant of the potential danger in these strange otherworldly forces.

A naturalistic ivory mask from the coastal Edo Kingdom of Benin (now in Nigeria – above) illustrates how local Africans experienced European arrival. This mask is identified with Benin Queen (Iyoba) Idia, the mother of King Esigie, the Benin Oba (king, r. c.1504–1550) who witnessed the first Portuguese arrival and probably commissioned this work. The Portuguese provided Benin royalty with aid in fulfilling

shared political goals. Queen Mother Idia had considerable power
and was considered an important political and military strategist.
Not only was Idia able to elevate her son to king above his more senior
brothers (from other wives), but she also increased Esigie's power
by encouraging the Portuguese to join his successful military advance
against Igala to gain control of critical Niger–Benue river confluence
area trade, which had long been held by the Yoruba Ife ruler. This
control provided Benin with far greater inland trade access, while also
making Igala in essence a tribute state to Benin. Ivory, a high-status
medium, befits a queen. This mask also bears iron inlays, a reference
to iron's ritual power and primacy. Four incised ivory marks extend
vertically above each eyebrow; women and foreigners are generally
accorded four such marks, Benin kings and other local men having
only three. The mask's hollowed back may have once held powerful
protective substances for which Idia was well known. Its ivory surface
conveys ideas of spiritual purity and the white (chalk-like) world of
Olokun, the Sea God.

After the Igala Kingdom was conquered by the Benin Kingdom,
the Igala king (Attah) recognized this alliance and tribute-state
status by wearing a bronze Benin pendant mask on formal occasions.
This work bears three marks above the eyes to signal the Igala king's
royal identity, despite being a foreigner. We can see here masking's
important role in addressing genealogies – both family-based
and delimited by historical political ties. In Benin, the Oba's first
official act on being named king was to create a memorial altar to
his predecessor, which then became central to his regular worship
in private and state ceremonies (page 18). The altar served as a site
through which offerings and words pass to the deceased. The corpus
of Benin bronze heads and other works displayed on royal altars
addresses socio-cultural, political and religious ideas about rulership
power, especially the head as centre of experience, leadership,
good fortune and success in life. The head is privileged in the royal
altarpiece dedicated to Oba Ewuakpe (c.1690–1713 – opposite),
shown here disproportionately large and in a European-style bowler
hat, wearing little of the traditional coral attire of other Benin kings
because of his political and economic impoverishment. This ruler is
depicted with idealized features like those distinguishing many Benin
portrait arts. In one hand the Oba carries an axe blade (a symbol of
power and death); in his other a decorated pestle (a symbol of well-
being). Ewuakpe, and this altarpiece, mark a transitional period here.

Imported European metals – rather than local copper (as was
likely the case at Igbo Ukwu and Ife) – are used in Benin copper
alloy casts. The reddish surface enhances the work's aesthetic and

Benin Igun Eronmwon bronze casting guild member
Altarpiece for
Oba Ewuakpe
Benin (Nigeria),
late 17th century
Copper alloy and
iron, 58 x 35 x 30 cm
(22⅞ x 13⅞ x 11⅞ in.)
Ethnological Museum
of Berlin

King Ewuakpe is accompanied here by two emaciated individuals (enslaved men), referencing a core incident in his reign when he lost power due to a nobility-invoked uprising, and only gained it back after beginning to sell enslaved individuals to European traders. Usually it is court figures who accompany the king on such altarpieces.

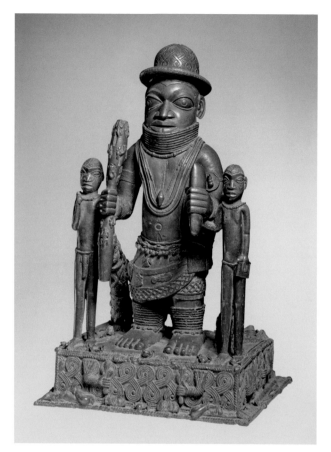

symbolic importance. Red is a royal colour, which also links to blood (both lineage and sacrifice) and is seen to keep danger away. Portraits made for lower-ranking chiefs were carved of wood sometimes enhanced with copper sheathing; those commemorating artists were of clay. Red coral used in jewelry here originates in the Mediterranean Sea and was among many imported goods reaching Benin during this international sea-trade period. Red coral jewelry in Europe had magical (medicinal and good luck) associations; in Benin, coral was linked to the ocean god, Olokun, the journey of the dead and ties of blood – affiliations via birth or political alliances. The top openings in these heads hold carved ivory tusks, whose motifs designate people and other motifs from Benin religious and political life.

DAHOMEY, YORUBA AND ASANTE

Dahomey (Fon) King Agaja, the son of the kingdom's founder
Huegbaja, is credited with greatly enlarging the state during his long
reign (1718–1740). Agaja also led a military attack against his main
trade competitor, King Haffon of Savi (near Ouidah), who controlled
European access along the coast. After this successful expedition,
aided by female warriors and Agaja's own daughter (who added water
to Haffon's critical gunpowder supplies), Agaja chose the European
sailing vessel as his royal symbol. One tops the memorial sculpture
(below) that is positioned as a roof finial atop the palace Spirit
House (*djexo*) to honour the late king's spirit during the months-long
annual memorial ceremonies. This work includes hammered metal
(silver) over a sculpted wooden core. This approach, characteristic of
assemblage techniques that were often celebrated by local Dahomey
artists in *bocio* and other forms, here made effective use of expensive
imported metal. Scientific studies of Dahomey art works with
silver cladding show remarkably low levels of silver in relationship

**Fon Hountondji
guild artist**
Xotagatin ship-form
roof finial for Dahomey
King Agaja
Fon, Republic of Benin,
early 20th century
Wood and silver,
height 23 cm (9⅛ in.)
Musée Africain de Lyon

**Agaja's ship-form finial
speaks to European
trade; it also addresses
the unconscionable
relationship between
the promotion of human
trafficking and the arrival
of luxury goods – such
as expensive cloth, liquor,
tobacco and firearms –
that defined court status
and well-being.**

Ayizo wood carver
Ayizo (Fon, Yoruba)
divination board
Republic of Benin,
16th–17th century
Wood, 34.4 x 55.7 cm
(13⅝ x 22 in.)
Museum Ulm

**Among the Ayizo, Fon
and Yoruba, divination
plays a role in guiding
decisions on short- and
long-term problems –
health, jobs, marriage,
children, accidents and
rulership succession. The
divination practice, called
Ifa (Fa), is under the
patronage of Orunmila
(guardian of wisdom
and knowledge).**

to alloys, conveying their unique artistry skills. This work, fashioned
from hammered European silver coins, is by the royal Hountondji
metalworkers' guild. It is part of the broader Dahomey tradition of
refashioning earlier works lost through fire or other means as part
of a 'renewed' corpus of ancestral works.

Divination forms of varying types are often central to
commissioning African art. Divination arts reinforce social values
in contexts of change. Atop every Yoruba and Fon Ifa divination
board is the face of Eshu (Legba), the messenger and trickster
deity who carries messages between humans, ancestors and gods.
Eshu sometimes intentionally misrepresents information, making
every transaction fraught. For this reason, Eshu is acknowledged
and honoured at every offering. As god of crossroads and markets,
he both clarifies and potentially subverts one's path in life.

This 16th–17th -century Ifa divination board (above), one of
the earliest extant ones, was possibly created by an Ayizo artist
from the Dahomey Kingdom's Allada area. It incorporates both
circular and rectangular frames (the two primary board shapes). The
complexity and diversity of circumference motifs suggest this board
was commissioned when Ifa divination was first being introduced
in Dahomey, replacing an earlier divination form featuring water-
and pebble-filled vessels. These figurative framing elements include
tappers of ivory or wood that call up forces to attend the divination
session, alongside diverse animals, humans and other forms addressed

in the 256 Odu systems of signs of Ifa. The single- and double-line linear marks designating each Odu sign are marked on the board surface after it is covered with *irosun* (termite hill) powder. Diviners read the patterns on such boards as communications from ancestors, gods and spirits to answer the questions a client has posed. Analogous Ifa divination forms are used broadly in the region – Igbo, Nupe, Benin.

Ifa's origins likely date to c.1200–1300, a time when visually similar systems were circulating. Under the Yoruba sponsoring deity of knowledge and wisdom, Orunmila, Ifa's origins trace to *al-Rami* (sand divination). The name Ifa may derive from *al-fa'l* (Arabic for fortune, good omen). Muslim Yoruba healers honour Algerian-born philosopher Ahmad al-Buni (d.1225), who draws on earlier Arabic and Latin sources, and there may also be connections, via Persia, to Chinese divination forms. However broad its sources and complements, today Ifa is a distinctively Yoruba and area institution. It functions as the basis for a complex local philosophical, religious and political system where a cross-regional association of Yoruba city-state residents shared a set of complementary beliefs and practices. The 256 Ifa signs evoke different regional primacies depending on site history, with Ifa diviners and clients addressing a broad range of local and broader issues that tie into Yoruba world views.

The Asante sacred 'Golden Stool' (*Sika Dwa Kofi*, 'Golden Stool born on a Friday' – below) embodies the Asante nation's spirit – past, present and future. The stool features in enthronement rites of the new Asantehene (Asante ruler), who is lowered and raised towards the stool without actually touching it. The throne is then positioned

Asante wood and gold sculptor
Asante Golden Stool on its royal chair during a ceremony
Ghana
Original stool, c.1700

In this photograph, the sacred throne is positioned next to the Asante king Otumfuo Opoku Ware II, turned on its side on a ceremonial chair. The array of bells, cast figures and other items speak to the history of Asante conquest and unification. Court officials bearing ritual swords, their handles outstretched to the front, are seated before the Asentehene and Golden Stool.

Asante gold caster
Asante 'Worosa' head
Ghana, c.1770s
Cast gold,
20 x 14.5 x 14 cm
(7⅞ x 5¾ x 5⅝ in.)
Wallace Collection,
London

**Gold head-form sword
ornaments of this type
are known as 'Worosa'
heads, named after
a northern Banda state
leader executed around
1765 for killing Asante
traders. Safeguarding
local and regional trade
routes was a vital
royal function.**

beside the Asantehene (the only person who may touch it), atop its
own chair, as it may never touch the ground. Like the sculpture on
page 96, the stool is not only a sculpture of hammered metal wrapped
around a sculpted wooden core, but is also a work that honours and
spiritually re-embodies an earlier one. Legend maintains that the
original Golden Stool descended from the heavens and landed at
the feet of Asante's founder, Osei Kofi Tutu I (c.1660–c.1717), after
a Friday gathering near a Kum tree. The priest Okomfo Anokye
informed the group that this golden stool contained the nation's soul.
In due course, other area official stools were replaced by exemplars
modelled after the curving-topped stool of this heavenly derived
one – a vital symbol of union. Gold not only sustained this system
but also encapsulated the life force and well-being of Asante people,
living or deceased. Osei Kofi Tutu I oversaw the transformation of the
historic gold trade from earlier trans-Saharan routes through Mali to
the Atlantic commercial network that saw the building of numerous
European trading forts along this coast.

Gold figured in other Asante (and larger Akan area) arts.
This cast gold trophy head (above) depicting a high-status enemy
military leader was once secured to an Asante ceremonial state
sword and featured in public displays. Honouring high-status

enemies was important. When Worosa's decapitated head arrived in the Asante capital, Kumasi, it served as the model for casting a gold version. The wear shown on this sculpture indicates it may date to the 1770s and perhaps represents Worosa himself. The beard indicates high status. In Benin, high-status enemy dead were similarly honoured with bronze heads. Positioning this head and other gold objects (miniature teapots, punch bowls or cannons) on state swords made the link between Asante war and trade access (alcohol, prestige goods, weapons) clear.

MALI, MOROCCO AND NORTHERN NIGERIA

In Mali, with the end of Mansa Musa's 14th-century dynasty, the powerful Songhai dynasty rose to prominence further east in the inner Niger River port city of Gao (now in Niger), also embracing Timbuktu and other centres. Under Songhai, Timbuktu retained its importance as a centre of trade and learning, as well as its identity as an axis to trans-Saharan routes leading to North Africa and beyond. A Songhai leader named Muhammad Ture (Askia Muhammad I or Askia the Great – r.1493–1538) was particularly powerful. Though not a member of the Songhai royal family, he became chief minister and

Songhai architect
Tomb of Askia
Muhammad I
Gao, Niger, c.1550
Earth and wood

Mosque megaphones affixed at the top now announce the daily call to prayer. Spiky mound surfaces, achieved through extended wooden branches, afford a ready scaffolding for men affiliated with the mosque to mount the surface for regular replastering. These wooden elements also help to draw moisture from the earthen interior, enabling its survival over centuries.

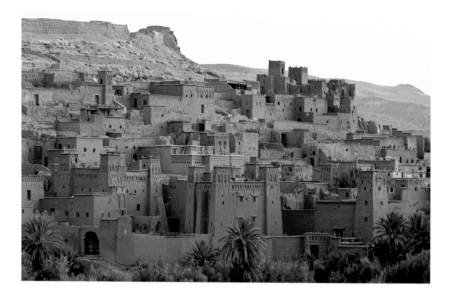

Amazigh architects
Ksar (fort residence) at
Ait Benhaddou Oasis
Morocco, 17th century

Kasbah earthen buildings
with 'missing-brick'
façade decorations reflect
the continuing wealth
of these large oasis
communities during this
key trade period. The
Moroccan government
has led the restoration
and preservation
of this domestic
kasbah (fortification)
architecture, with some
examples now serving
as popular cinema
backdrops.

deposed the ruler's son whom he once served. Renowned as a military figure, leader of a 3,000-man cavalry bodyguard, Askia Muhammad expanded Songhai – subduing states east, west and north, including the valuable Sahara salt mines. At his death, his successor, Askia Ishaq I (r.1539–1549) erected a large earthen pyramidal memorial to honour him (opposite); steps around the perimeter allow access to its height. The structure recalls the great Egyptian pyramids, which the ruler no doubt saw on *hajj* travels (1497–8). It also recalls the dome-shaped shrines of many North African saints and local conical West African shrine mounds that provide ancestors, spirits and deities with shelter. In 1591, the Songhai dynasty lost control of its salt mines and its long-time role in the trans-Saharan trade, with Amazigh continuing to oversee these sites and routes. North of Timbuktu, Sahara-linked architecturally rich oasis centres became important locales for both caravan travel and art, filled with stunning fortifications bearing beautiful façades (above).

Many Amazigh rock art examples are located near where these caravans and other Saharan travellers might see them

Further east, around Lake Chad, in Hausa, Bornu (former Kanem-Bornu) and affiliated northern Nigeria and Cameroon

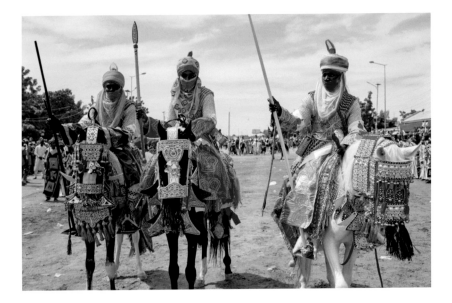

communities, a medieval and continuing tradition of richly
armoured cavalry (and sometimes chainmail-protected riders)
celebrated royal political status and equestrian performative arts
(above). Multi-coloured protective attire for both horse and rider
was fashioned from thickly layered cloth appliqués, embroidered
together in bold asymmetrical patterns. The origins of this tradition
lie further east in medieval Egypt and Sudan and likely arrived here
from the overland east–west route from Lake Chad to the Nile.
Granada-born, Fez-raised Amazigh traveller Leo Africanus (al-Hasan
ibn Muhammad al-Wazzan Al Fasi) travelled to the Lake Chad area
in the early 16th century. Here, in what he identified as the Gaoga
Kingdom, Africanus met an Egyptian traveller, bearing expensive
goods to this ruler – well-trained horses, chainmail and firearms.
Ivory, enslaved people and local goods were traded in turn. Leo
Africanus described Gaoga as a Christian kingdom, and some areas of
Bornu (Chad and northern Nigeria) were likely also Christian in this
period. Medieval era Kanem-Bornu and Sao earlier lived near here.

**Daura Hausa equestrian
performers during Gani
(Durbar) festival**
Daura, Katsina, Nigeria,
early 21st century

The modern Hausa
Gani (Durbar) festivals,
in which equestrian
performers today
appear, likely date to
the Medieval period
(Kanem-Bornu and
other), a time when
both Islamic and Coptic
influences (including
cavalry) were in play.

EAST AFRICAN CIVILIZATIONS

The decorative motifs on elaborate wooden doors carved since the
late 17th century along the Swahili coast of Kenya, Somalia and
Tanzania (opposite) reflect a complex mix of cultures and ideas. Most
surviving examples date to the 19th century and were commissioned

by privileged elites in cities like Lamu and Stone Town, Zanzibar. Decorative door features vary from abstract geometric patterns replete with calligraphic and arabesque elements to natural forms like rosette patterns, lotus flowers (prosperity symbols), rope and palm trees. These decorations complement the larger Indian Ocean setting – African, Arabic peninsula and Indian. Doors from Zanzibar tend to be carved in higher relief and include more figural elements. Some elites commissioned doors directly from artists in Mumbai and elsewhere in India.

The buildings to which these doors were affixed were fashioned from harvested sea coral, adding a reddish hue to Stone Town and other centres

Zanzibar was well known for its trade in ivory. They also traded humans from inland African areas. Powerful sultans like

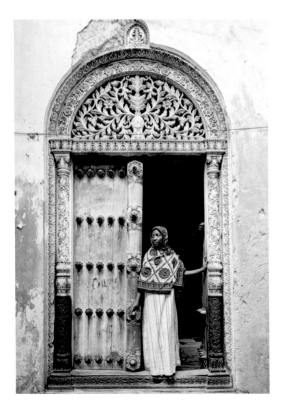

Swahili wood carver
Door
Stone Town, Zanzibar,
Tanzania, 19th century
Wood and metal

Some door motifs, such as fluted columnar elements and Corinthian capital-like forms, reference European architectural prototypes. Vine patterns (vegetal scrolls) or a decorative pot with a plant, seen in Zanzibar elite examples, are said to represent spice trade interests, consistent with wealth generated through planting, harvesting and trading spices – now important international commodities.

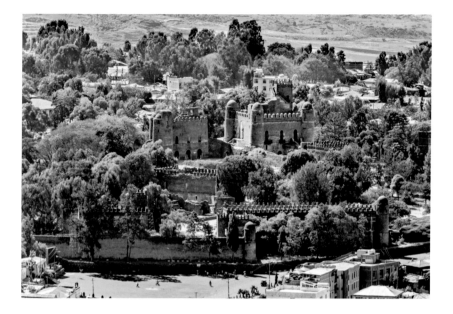

Barghash ibn Sa'id (c. 1834–1888), and wealthy traders, including the famed slave trader Tippu Tip (1832–1905), had especially elaborate doors like this on their residences. Zanzibar and nearby Kilwa Island had came increasingly under Portuguese control, eventually becoming a Portuguese tribute state under Vasco da Gama (1469–1524). In 1505 fires destroyed much of the town. In this same century, a fort (Gereza 'Prison' Fort, also called Arab Fort) was built near where the palace once stood, a visual reminder of the abhorrent legacy of slavery. Omani rulers eventually supplanted Zanzibar's local dynasty, and in 1784 conquered Kilwa, later controlled by the French, then Germans (1886–1918) and then the English prior to independence.

Very different factors and art historical developments played out to the northwest in Ethiopia and its new centre at Gondar (1632–1855, above). This site was occupied as a religious and political capital by a series of emperors, beginning with Fasilides (r.1632–1667) and extending through Iyasu II (r.1730–1755). Until the 16th century, Ethiopian emperors had no fixed geographic capital, instead moving from one temporary site to another, creating impermanent structures as they relocated. In 1559, under Emperor Menas, leaders began to return to a Lake Tana Christian site (near the earliest churches and existing manuscripts) during rainy season months. In c.1635, Fasilides founded Gondar, after following a buffalo to the nearby pool. The centre was called a *katama* ('camp') – recalling earlier

Amhara architects
Royal centre of Gondar
Ethiopia, 17th century

This complex assemblage of buildings was surrounded by a wall pierced by 12 gates whose names evoke the centre's many activities – Judges, Spinners, Queen's Attendants, Musicians, Privy Chamber, Calvary Leader, Pigeons and Gifts. Near the walled centre of Gondar was the main market and troop assembly area.

royal impermanent settlements. In addition to constructing a castle, Fasilides founded seven churches. Five subsequent emperors also constructed palaces here.

By the 17th century Gondar's population had grown to about 60,000. Here the now dominant Ethiopian Amharic culture grew and thrived. During his reign Emperor Fasilides sought a far more isolationist policy, ending Ethiopia's trade and diplomatic ties with Europe. Fasilides formed an alliance instead with coastal Muslim rulers and reinstituted ties with Ethiopia's own Christian church. The new capital at Gondar helped safeguard the area from outside missionizing efforts and invasion from largely non-Christian Galla populations to the south. The Gondar building complex, called Fasil Ghebbi (based on the Amharic term for compound or enclosure), includes not only Fasilides's castle, but his successors' residences, along with churches dedicated to different religious figures, a court, a banqueting hall, a library, baths and horse stables. The centre reflects diverse building styles – Nubian, Arabic, Hindu and Jesuit Mission Baroque. Indian workers were among those involved in its construction. In 1668, a church council decision divided Gondar's inhabitants into distinct religious and cultural quarters, complementing quarter divisions in centres like Jerusalem. At Gondar, these included Muslim, Beta Israel (Ethiopian Jews), church hierarchy and nobility. After 1769, while emperors continued to reside here, local governors from other Ethiopian areas became the most powerful rulers.

KEY IDEAS

During the Early Modern period, many power centres shifted to the coasts where a myriad of European forts was built, providing luxury goods and arms in exchange for increasing numbers of enslaved people.

External enslavement practices and new armament forms brought hardship to many areas, with missionary and conversion activities increasingly connected to trade.

Imports of bronze and iron encouraged new art productions – castings and other sculptures.

Ranking opponents killed in battle were sometimes honoured with prestigious arts.

KEY QUESTION

What artistic practices are in play in other African areas that may not have faced direct impacts of coastal and other enslavement-related events?

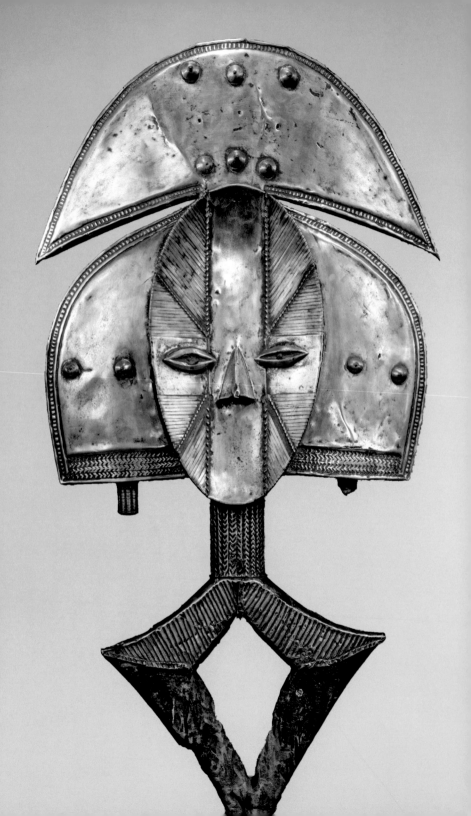

HISTORIC LEGACIES
(1650–1950 CE)

-

Long Ago did not live long ago

-

Zimbabwe proverb

This chapter explores three especially important regional contexts where art works cross between historic periods. Each region is shaped by a major river network system: the broader Congo Basin and the adjacent Atlantic area; the Niger–Benue river system of Nigeria; and the Inner Niger River system, which courses through what is now Mali. Many of the works explored in this chapter were once called 'traditional' or 'classic' African art, implying that they never changed. But they clearly have changed, although aspects of their longevity beyond the 19th and 20th centuries are an important part of this heritage. Many of these works were actively collected in the colonial era, either by families or communities that converted to 'outside' religions (Christianity, Islam) or as part of large-scale Western scientific expeditions, as well as for the sizable financial remuneration of local African and outside art traders. These works display not only the striking creativity of African artists, but also how important these forms remain for local residents and outsiders alike, despite opposition by some religious groups who see them as potentially dangerous icons of a religious era now largely over.

Congo Basin art provides a lens into how localities address issues such as death and memorials, community leadership and the acknowledgement of history. In the Niger–Benue confluence area, these factors are important too, as are rituals of royal transition, agricultural harvests and ceremonies honouring the ancestors that bring communities together. In the Inner Niger River area, we experience not only the importance of privileged knowledge expressed in art but also the vital role of agriculture (planting and storage). We see many regional and cross-regional art complements. Today most African scholars choose not to employ more pejorative terms 'tribe' or 'tribal', not only because hard geographical and style distinctions rarely exist, but also because it is more accurate to frame these ideas in more regional concepts such as cultures, civilizations, societies, professions or associations. While not all these arts are still being produced, many of them are, although few still play the same precise roles. Contemporary African and other artists increasingly turn to these historical regional works.

THE BROADER CONGO BASIN
(GABON, CONGO, ANGOLA)

The area defined by Central Africa's vast Congo River system and the broader nearby equatorial region gave rise to many important arts. This region includes both heavily forested areas and grassy

savannas. It once was primarily occupied by Mbuti, Batwa, 'Pygmy' and other nomadic groups. As Bantu-speaking communities migrated here, bringing new technologies and cultural values, special healers (Nganga) emerged. While the Kongo state, among others here, developed in Medieval times, its importance continued into the Early Modern and colonial eras and beyond. By the 17th and 18th centuries, other large kingdoms had emerged – Kuba, Luba and Chokwe/Lunda – each with rich, vibrant court arts. Colonial-era changes – new crops, leadership models, strategic alliances and financial benefits resulting from cross-regional trade routes – had an important impact.

Okak Group wood carver
Fang *bieri* female figure
Gabon, 19th–early 20th century
Wood and metal,
64 x 20 x 16.5 cm
(25¼ x 7⅞ x 6½ in.)
Metropolitan Museum of Art, New York

As well as suggesting a female form, this sculpture's body and facial features also suggest an infant's fleshy body; both ideas are consistent with the roles ancestors play in bringing new births (children) into this world.

In Gabon, one ongoing issue was how to memorialize the dead when every few years one was moving to new agricultural sites. Portable Fang and Kota memorials address this issue in a visually powerful way. These served as visual loci affixed to baskets or boxes containing relics of important ancestors. The sculptures, carried and performed by village leaders for related ceremonies, speak not only to family genealogies but also to the ongoing roles of art in sustaining historical ties. The Fang example (previous page), known as a *bieri*, is noteworthy in its replication of ovoid shapes, showing the arms to be at once those of an infant and an adult with pronounced musculature. Present, past and future are all suggested here. The Kota work (below), known as *mbulu ngulu*, displays a more two-dimensional form featuring a composition of angled lines and curves, with a minimalized waist and broad shoulders. Both figures share concave oval-shaped faces and similarly shaped eyes (typical of the Gabon area).

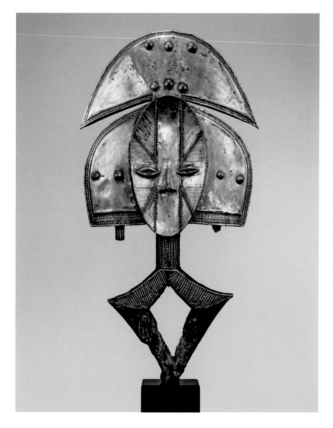

Kota artist
Reliquary figure
(*mbulu ngulu*)
Gabon,
19th–20th century
Wood, copper and brass,
73.3 x 39.7 x 7.6 cm
(28⅞ x 15⅝ x 3 in.)
Metropolitan Museum
of Art, New York

The sculpture's copper-clad convex face is framed by an outward- and upward-angled coiffure and crest. The contrasting copper-based colours and angled positioning of the metal sheathing draw attention to the face and recall copper's importance here as a valued trade good.

Yombe Kongo artist
Mother and child figure
Democratic Republic
of Congo, 19th–20th
century
Wood, glass, upholstery
studs, metal and resin,
27.9 x 12.7 x 11.4 cm
(11 x 5 x 4½ in.)
Brooklyn Museum,
New York

**One tradition maintains
that a well-known
midwife commissioned
the first *phemba*, the
name denoting the
spiritual world's role
in conception and an
infant's connection
with it. In many such
works, the baby's eyes
are closed, as if dead,
a reference perhaps to
higher infant mortality
rates under the colonial-
era disruption.**

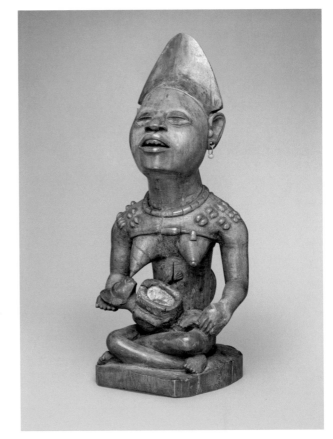

One tradition of lower Kongo works comprises wooden mother-and-child figures (above) that honour not only a family's deceased elder, but also lineage founders – the women from whom these matrilineal male rulers derived their political power. The elaborate, high coiffure denotes an elite person. These Yombe Kongo sculptures were maintained in lineage shrines or by diviners. The platform where the female figure sits recalls those used for Kongo kings. The eyes are embedded with reflective glass, promoting viewer engagement and heightening the emotional potency. The work's generic name, *phemba* ('white'), references the light wood colour and more specifically the coolness of the streams that give access to the ancestral world. The figure's mouth is slightly open, as if speaking. The mother's manner of cradling the baby in her arms complements some Christian Marian imagery, reflecting perhaps early missionizing.

111

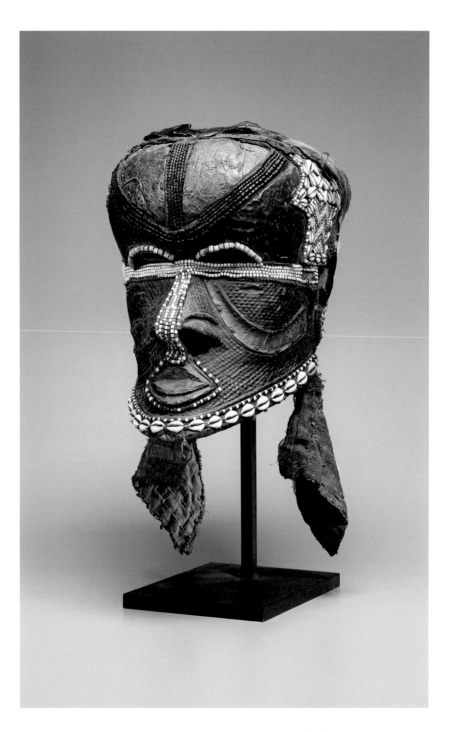

Kuba artist
Mboom mask
Democratic Republic
of Congo, 19th–20th
century
Wood, glass beads,
copper, monkey fur,
cowrie shells and raffia
cloth, 32 x 26.5 x 31.5 cm
(12⅝ x 10½ x 12⅜ in.)
Yale University Art
Gallery, New Haven

**This mask recalls legacies
of the indigenous
residents who found
the mythic basket of
wisdom, as well as local
nature spirits (mingesh).
It is employed in royal
performances referencing
the kingdom's founding.**

A Kuba royal myth addressees the culture hero Woot as having
drunk palm wine and losing the basket of wisdom provided by the
creator deity, Mboom. A member of the local Batwa/Twa 'Pygmy'
population found this basket and conveyed it to Kuba's c.1625
founder, Shyaam aMbul aNgoong. Like myths about the ruler's travels
to other regional political centres, this legend serves to validate land
appropriation and expansion of the new ironworking and agricultural
populations, reflecting Bantu-speaking migration into this area.
Woot is celebrated in a Kuba mask that also references Mboom
(opposite). This mask displays the wider forehead of a 'Pygmy', his
chin shown raised and bearded – a symbol of eldership. The mask
faces upward, as if someone was looking down on him from above.
One particularly important geometric textile and carving design
here, an interlocking pattern, symbolizes Woot himself.

The Luba Kingdom to the south was founded by Kongolo
Mwamba around 1585 near the still-important copper mines.
The Luba developed an important new governance model with the
institution of a regional council (Mbudye), later taken up by the

Luba artist
Lukasa memory board
Democratic Republic
of Congo, 19th century
Wood, beads and metal,
height 34 cm (13⅜ in.)
Private Collection

**The human head at
the top of the board
references chiefs,
important ancestors and
Mbudye affiliates. The
overall board shape, with
its corner extensions
and tail, suggests the
crocodile, at home on
both land and water,
referencing the symbiotic
relationship between
Mbudye leaders and
ruler (framed here as
the owners of the land –
kaloba).**

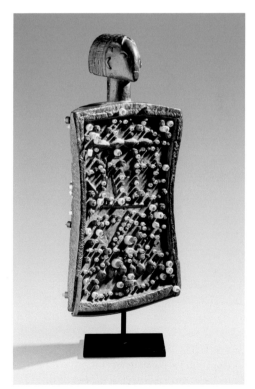

Chokwe and the larger Lunda empire. Luba memory boards (*lukasa* – previous page) served as symbolic maps featuring the larger history, landscape and socio-political relations of this polity. Each such hand-held object is unique, assuming its features after divination with an adept or spirit medium. Such works belong to Mbudye members charged with maintaining and guiding Luba state politics according to historical principles; such individuals, both male and female, serve as a counterbalancing force to local rulers. Mbudye members rise in ranks as they achieve higher knowledge levels, with only the most advanced members able to create or decipher the *lukasa*'s symbolic motifs. Design elements (curves, circles, rectangles) delimit buildings such as a royal compound or Mbudye meeting house. A diamond or chevron recalls Luba spirit capitals (*kitenta*) where tombs of past kings are located, or the turtle's carapace (suggesting the founding female ancestor identified with turtles). The tradition of moving capitals to sites once occupied by earlier dynastic rulers is shared with Kongo, Kuba and Chokwe communities. The Lunda royal capital plan itself is in the form of a turtle, an animal known for longevity and mobility.

THE NIGER–BENUE AREA OF NIGERIA (IGALA, BENIN, YORUBA, IGBO)

The Niger–Benue river confluence area (now Nigeria) produced many remarkable arts over its long history. What distinguishes these cultures is the development of uniquely creative artist workshops centred on specific technologies – from ironworking to bronze casting, handsome ceramic forms and complex wood carvings. Vast empires and states (Benin, Hausa and Yoruba) emerged, along with dynamic non-royal titled elder leadership governing structures (Igbo and nearby groups). Trade along the Niger and Benue rivers was extensive. Early 19th-century British explorers noted that there was twice as much river traffic here as in upper parts of Germany's commercially important Rhine River. Local and regional trade remained important, creating large urban polities and population densities where artist guilds and professional specialists benefitted from well-financed year-long patrons – kings, religious associations and others.

Igala art traditions signal their importance in regional political history. The Igala Kingdom long controlled the eastern bank of the Niger–Benue confluence area. From this region, other groups – most notably Yoruba and Nri Igbo – trace their ancestry. Igala Agba helmet-form masks (opposite) are sometimes distinguished by beautiful vertical-line facial markings, recalling the facial patterns

Igala wood carver
Igala helmet mask
Nigeria, 19th–20th century
Wood, height 33 cm (13 in.)
Private Collection of Wolf-Dietrich Nickel

Agba masks were worn at festivals celebrating royal lineage founders (and current leaders) and for related funerals. Igala masks address both royal and non-royal histories, since some masquerade traditions were introduced through military victory. Whether referencing an actual battle context, or simply wars' importance in disseminating art forms, these works speak to histories of place and transformation.

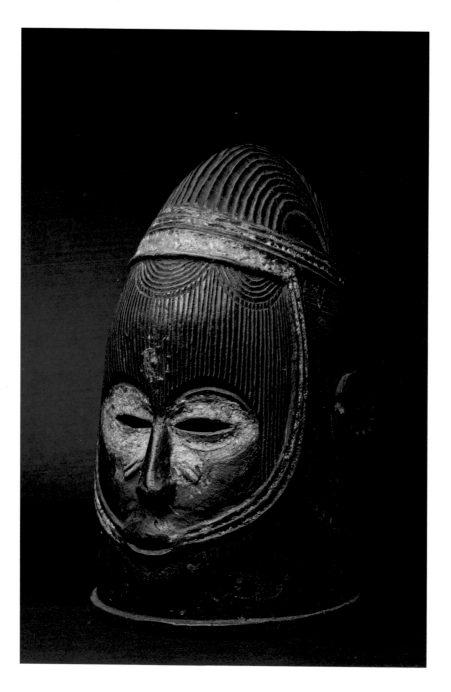

of 1st-dynasty Ife Yoruba leaders in c.1300 CE arts. These shared motifs speak to close kinship ties between these cultures, as does their language (60% cognate elements) and history. Igala Agba masks were worn in annual ancestor-linked Egu performances (like closely related Yoruba Egungun masquerades). They also appeared at annual New Yam (harvest) festivals honouring the ancestors. The tradition of yearly masquerades honouring the dead is still found in the Igbo area. The fact that several Yoruba-linked Ife sculptures were long housed at Tada, near Igala's capital (Idah), speaks to these regional connections, as does the large cast copper alloy archer from the same casting group from the nearby Niger River island site of Jebba that shows Igbo Nri facial markings.

A 17th–19th-century Owo Yoruba ivory bracelet (below) was used in royal coronation rites addressing this kingdom's ties to rulership in Ife, the Yoruba Empire's long-time capital and kingship origins site. Featured prominently is a fish-legged form

Owo Yoruba ivory carver
Owo Yoruba royal
bracelet
Nigeria,
17th–19th century
Ivory, wood or
coconut shell inlay,
19.1 x 10.5 x 10.5 cm
(7½ x 4⅛ x 4⅛ in.)
Metropolitan Museum
of Art, New York

**This bracelet was worn at
Ore rites identified with
Owo origins at Ife. Here
we see a fish-legged
siren-like figure whose
outward-splaying legs
transform into mudfish,
a transformation theme.
In some fish-legged
imagery he holds aloft
(in a taming gesture)
crocodiles or leopards.
Or, as here, a dangerous
crocodile is shown
nearby.**

(siren/merman – a split-legged figure with fish-like feet) identified here with the god Olokun. In the Yoruba context, these sirens are often coronation-linked and appear in arts of the powerful Ogboni and Obalufon associations. In the Benin Kingdom, sirens are associated both with Olokun and with an early paralysed king, Ohen, though generally kings are portrayed with 'perfect' bodies. Similar split-legged siren forms are seen in earlier African arts elsewhere – including Horus cippi, magical stelae made in Egypt's late international period (page 49). Split-legged sirens also feature in Greco-Roman and medieval African forms (including Coptic textiles), suggesting how far these motifs have travelled within Africa. After 1450, the siren motif may have arrived anew via European ships and printed matter.

Split-leg fish-legged figures convey the broad geographic trans-historical reach of unusual motifs, particularly along the east–west Lake Chad to Nile Valley route

Igbo artists interacted with their neighbours – the Igala, Yoruba and Benin – over many centuries. Igbo are an indigenous agricultural, trading and artisan population who were involved in commerce east of the Niger River and below the Benue very early. Some Igbo lineages share the legacy of divinely sanctioned priest-rulers; other Igbo groups are led via titled elders, selected through their own achievements and family support. Individual initiative and the force of one's own hand are honoured as models of victory and success. Igbo masquerades (overleaf), like Yoruba and Igala examples, help unify the community (past and present), celebrating family, religious and social bonds in contrasting aesthetic forms that express both unity and difference. White-faced Igbo masks (Agboho Mmwo, among others) are identified with white-haired elders but incorporate the idealized features of young women with complex coiffures, rich body-decorating patterns and elaborate costumes. These 'beauty' masks are generally dressed in richly coloured and patterned body-adhering attire. In contrast, the dark-faced beastly maskers who personify the sometimes-unruly youthful men wear masks featuring dangerous animals, disease attributes or skeletal imagery, as well as a long costume of raffia grass. Together the costumes signal contrasts between cultural values and power-linked needs – and how the two sit in balance. Female personas display delicate, carefully choreographed steps; the male beastly

masquerader actions are more individualistic and aggressive. Both performers honour ancestors returning to the village to help celebrate the New Yam harvest and other events.

In the nearby Cross River area, home to Ejagham, Boki and other cultures, we see carved wooden skin-covered headdresses that are worn by various age-specific or skill-delimited associations, some specialized in hunting dangerous animals, others comprising titled men. Occasionally these headdresses are Janus (opposite), with two heads. Sometimes Janus faces are a different colour (one dark, the other light), suggesting contrasting values, like nearby Igbo masks. The faces themselves are highlighted by raised keloid discs and markings evoking *nsibidi* symbolic writing, recalling earlier *akwanshi*

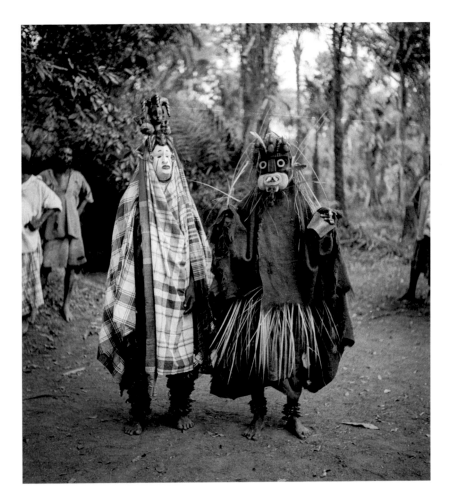

Ejagham wood carver
Ejagham Cross River
Janus headdress
Nigeria, 19th–20th
century
Wood, hide, pigment,
cane, horn and nails,
52.1 x 47.3 x 33.7 cm
(20½ x 18⅝ x 13¼ in.)
Metropolitan Museum
of Art, New York

**Two-faced headdresses
held added power as
they were linked to extra
sight (seeing in two
directions) or enhanced
insight (knowledge from
two worlds – earthly
and spiritual). The skin
covering is largely from
antelope pelts, soaked
then stretched over the
wooden core. Added
horns or braided coiffures
are also common.**

**Igbo wood carver and
performance artists**
Igbo Okorosie
masquerades
'Beauty and Beast' masks
called Nwanyioma and
Akatakpuru
Isuama group,
Nigeria, 1931
Photograph by
anthropologist Gwilym
Iwan Jones (1904–1995)
Museum of Archaeology
and Anthropology,
University of Cambridge

**Such masks address ideal
moral and leadership
values ascribed to
white-haired elders and
ancestors. Contrasting
masks feature black
or brown surfaces and
disharmonious features
suggesting youthful
power, nature and
night-time.**

stone menhirs that continued to be used into the 20th century. These
mask-wearers performed during funerals of high-ranking people.

WESTERN SUDAN AND THE INNER NIGER AREA OF MALI (BAMANA, SENUFO, DOGON)

In West Africa's savanna region, in what is today Senegal, Mali,
Burkina Faso and northern Côte d'Ivoire, many remarkable cultures
and art traditions emerged. The legacy of Islam also has left an
imprint, particularly on architecture, while many sculptural and
other arts continued to thrive. Watered by the powerful Niger
River and its tributaries, this is an area where agriculture was
independently invented. Ceramics and ironworking were and
are important, generally controlled by family- or lineage-linked
caste-like workshops, with women becoming potters and men
serving as blacksmiths and wood carvers.

 One art form that speaks particularly to the region's unique
landscape and history are carved headdresses known as Ciwara
(a half-human, half-animal being), created and performed generally
as paired mask forms by the Bamana in Mali (overleaf). Female
Ciwara headdresses are distinguished by straight (potentially lethal)
horns that recall the protective ones of female roan antelopes.

Bamana blacksmith and wood carver
Bamana Ciwara mask pair
Mali, mid-19th–
early 20th century
Wood, metal, brass
tacks and grasses, left:
98.4 x 40.9 x 10.8 cm
(38¾ x 16⅛ x 4¼ in.);
right: 79.4 x 31.8 x 7.6 cm
(31¼ x 12½ x 3 in.)
Art Institute of Chicago

These mask pairs reference large male and female roan antelopes, whose territory was appropriated by Bamana ancestors when they cultivated local fields. The two performers appear as pairs on agricultural fields during cultivation and planting competitions that honour the autochthonous land dwellers and spirits, as well as at celebrations of marital unions and family.

Male Ciwara headdresses have backward-curving horns, recalling male roan antelopes' rounded horns deployed in mating season battles. Female headdresses frequently show a baby antelope on the back of the main animal figure, recalling how Bamana and other African women carry infants.

The openwork zigzag male headdress patterning symbolizes water and the sun – both important to agriculture

Ciwara performers, draped in dark fibre costumes soaked in mud, hold two short sticks, suggesting the four-footed antelopes and the bent-over positions of farmers cultivating the hard earth with short-handled iron-bladed hoes. These hoes are also reflected in Ciwara head shapes. The performance posture references the belief

Bamana artists and ritual specialists
Boli sculpture
Mali, 20th century
Wood, bark, cloth, clay and blood conglomerate, height 66 cm (26 in.)
Los Angeles County Museum of Art

***Boliw* are fashioned around a wooden substructure covered with cloth, and more layers are added, so they grow over time. Plants, animal blood, mashed kola nuts, cooked cereal, liquor, special muds and clays provide added potency. Evoking an encyclopedia of the world, *boliw* also suggest a world inside out – cloth on the inside and materials linked to body interiors on the outside.**

that Ciwara introduced farming to Bamana ancestors, but due to their wastefulness and carelessness, the spirit buried itself in a field in anger. Ciwara masquerades honour Ciwara's work, as well as this god's sacrifice, and that of all Bamana farmers. The performers' positions may also recall the subservience and suffering of these farmers during the Mali Empire, when farmers provided food for the state.

Ciwara headdresses are also linked to the Bamana sculptural tradition called *boli* (*boliw* pl. – below). *Boliw* are power objects that encapsulate the spirit and vitality of core community religious forces. For example, after the death of the mythical Ciwara, a *boli* was created as a site where its spirit resided. Similarly, in some instances, a small *boli* is attached to the front stick-form 'horns' of Ciwara maskers. Commissioned, maintained and enhanced by powerful local men's associations like Komo, *boliw* are used to harness spiritual energy (*nyama*) and redeploy it for protective and healing purposes, and to hunt out criminals, sorcerers and other malevolent forces. These accumulative, solid, opaque and mysterious forms can be abstract or portray humans or animals (hippos, wild buffalos).

Horizontal Bamana Komo masks and their Senufo counterparts (overleaf) feature in initiation contexts for senior men comprising the powerful regional Komo associations. With massive wide-open

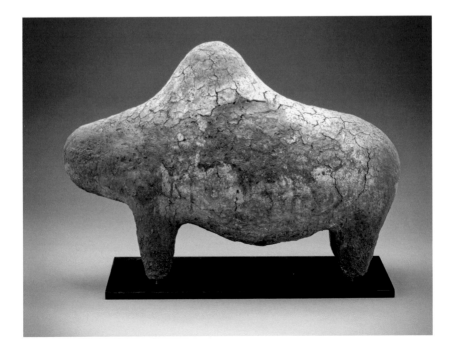

Senufo wood carver
Senufo Kòmòkun (Komo)
association helmet
Côte d'Ivoire,
mid-20th century
Wood, glass, animal
horns, fibre and mirrors,
43.2 x 40.6 x 68.6 cm
(17 x 16 x 27 in.)
Dallas Museum of Art

**Often called 'fire-spitter'
masks, because of the
burning coal inserted
at the top, these masked
personas find and distance
community harm.**

jaws and a surface prickly with animal horns, warthog tusks, porcupine quills, feathers and extracts of medicinal plants, these works' menacing looks seek to awe onlookers with Komo esoteric knowledge and power. The masks continued to hold power even after Islamization, and indeed, some of these powerful horizontal masks helped advance Islamic expansion. Among the Senufo, the Lo (or Poro) men's association created complementary headdresses (called *kponyugu*). During Lo/Poro initiations, young men learn not only about spirituality and social norms but also about the importance of leadership and community, so that they become responsible society members.

Elaborately carved Senufo doors (opposite) were secured to Poro/Lo sacred grove shrines storing these arts. Similar doors were commissioned by wealthy and influential men as prestige objects. This door, like others, displays mythological and cultural themes. They feature scenes of animals from local origin myths (here a turtle). The top and bottom registers include Senufo *kpelie* face masks and hornbill headdresses used in funerals and entertainments honouring elders and recalling their wisdom and ability to counter negative elements impacting families and communities. Other doors often feature men on horseback with weapons, a scene perhaps from the hunt and linked to issues of men's lives and how humans and animals are interlinked.

**Yalokone Senufo
workshop from Boundiali**
Senufo door
Côte d'Ivoire, 1920s
Wood
Private Collection

**At the door's centre is a
navel, extended into four
lined forms (creating an
X pattern) like women's
belly scarification
patterns, symbolizing
social and natural order.**

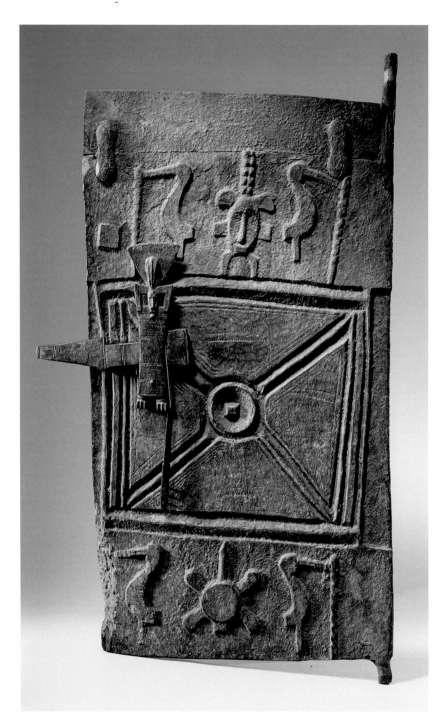

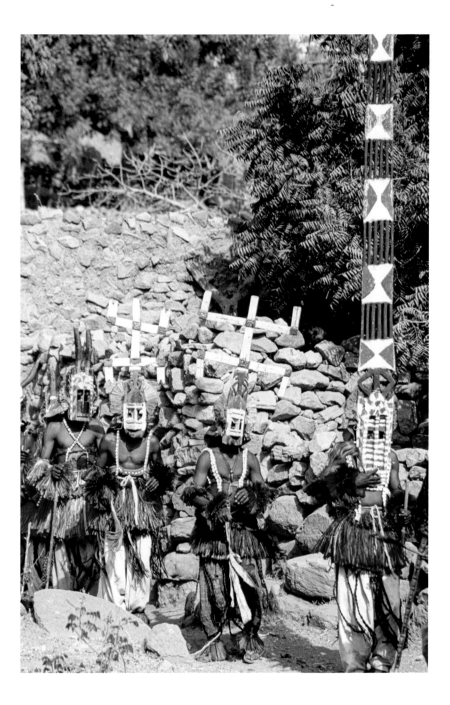

Dogon performance artists
Dogon masquerade featuring *sirigue*, Kanaga and antelope mask portrayals

These masks are made by young men who have been initiated into the Awa, an age-graded association, and are performed during Awa events and elders' funerals. In the latter, each family commissions the performers they can afford, often including mask types important to the individual's life. These and other masks also appear during the once-in-sixty-year Sigi ceremony honouring an entire generation.

The Dogon reside in Mali's remote Bandiagara escarpment and share with their Bamana and Senufo neighbours core art and cultural traditions – including Gur/Mande language ties, consistent with the Dogon's history as a refuge site over centuries of warfare and enslavement. In some ways, Dogon communities created a utopian societal model, countering this disruptive legacy. Dogon masks feature in funerals and other occasions both in village locations and on the flat earthen terrace roof of a deceased's home where different masquerade types perform together. Leading the group in the picture opposite is the tall, plank-like *sirigue* ('storeyed house') mask, signalling the lineage head's home ('great house'), whose façade bears a grid-like niche pattern that distinguishes it from other community homes. During performances, the *sirigue* masker adroitly swings this tall mask up and down to touch the ground before and behind him – a gesture reflecting the union of earth and sky, current and past residents. Behind the masker are several Kanaga masks distinguished by two horizontal arms on a vertical shaft. Kanaga mask performers create broad twirling motions around their bodies, suggesting the universe's ongoing, ordered movement and temporal change. Kanaga masks themselves are identified variously as a crocodile (the animal leading Dogon migration), a bird in flight and a cosmic symbol. Behind this mask grouping are various animals – in this case antelopes, but also frequently rabbits, hornbill birds and others. These honour local game felled by now deceased hunters. Some Dogon masquerade arts depict strangers (outsiders) such as Fulani (Fulbe) pastoralists who herded their cattle through the Dogon area. Fulani women sold their milk to Dogon residents. In some places their relationship with local agriculturalists was fraught as grazing cattle sometimes destroy cultivated field crops.

One of the most iconic Dogon sculptures is a couple seated atop a stool (overleaf). This male and female pair display both complementary and competing elements, identifying them as an idealized or primordial couple. The woman carries a baby on her back; on the man's back is a quiver, evoking the different roles each gender assumes – one as life giver, the other as life taker. Both are necessary to sustain and safeguard the community. The man wraps his right arm around the woman's shoulder, a protective and supportive gesture. His right hand touches the female's breast, signalling her role in feeding their young child; his left hand gestures to his penis, symbolizing the male procreative role. He wears a beard (a male status and elderhood marker); she wears a lower lip labret as jewelry. His prominent pectoral muscles parallel her breasts. Both have prominent navels and complementary coiffures. This carving, like earlier Tellem

figures, balances stylistic idioms through the dynamic play of negative and positive spaces and both frontal and profile surface details. The references to the continuity of life are reinforced by the stool on which they sit. Here four paired outward-facing ancestral figures (*nommo*) are joined centrally by a column that both unites and separates the stool surfaces, creating a world image symbolizing order.

Architectural traditions here are also of unique visual importance, including the tradition of open-walled roofed shelters (*toguna*) piled high with drying community millet (sorghum) where village elders meet to discuss various concerns of the day (opposite). Often positioned at the top of the village, these structures provide ready views of passersby in the areas below. They speak to the complex

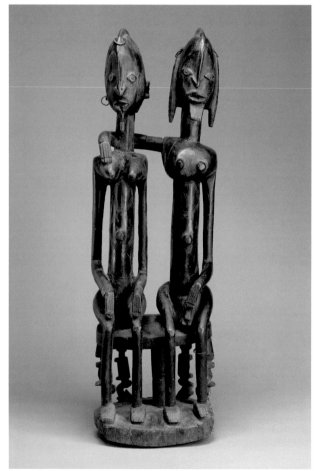

Dogon wood carver
Dogon couple seated on a stool
Mali, 18th–early 19th century
Wood and metal, 73 x 21.9 x 20.3 cm (28¾ x 8⅝ x 8 in.)
Metropolitan Museum of Art, New York

The numbers two, four, eight and sixty-four are important to Dogon as numerical complements to order, the pairing and/or other details of Dogon sculptures often reflect this. The support figures co-join this world and the ancestors, and the intermediary roles ancestors play for their living family members. Traditionally such sculptures were kept in family compound granaries and brought into the open compound area for harvest time and other ceremonies.

Dogon builders
Toguna (men's house)
with nearby homes
Bandiagara escarpment,
Mali

**Bas-reliefs or murals
portray masks recalling
those performed to
harness the life force
spirit (nyama). In cliffs
above the toguna are
cave-like crevices used
for burials, storage or
safe haven in times of
difficulty, accessible
by ropes.**

geo-spatial, multi-generational and religious values that inform this
area and its arts. While Dogon communities were under the leadership
of chiefs (Hogon) often depicted on horseback, much of community
control lay with local lineage elders such as those who met daily in the
toguna. Food storage was important to Dogon survival strategies in
this remote mountainous setting, and traces of millet flour and beer
offerings often are seen on adjacent altars. The wooden support posts
of *toguna* structures historically showed humans with the raised-arm
prayer gesture of Tellem sculptures joining time and place.

KEY IDEAS

Regional settings are important for understanding local arts.
Adjacent large river systems carried ideas and art forms broadly.
Skilled guilds and caste-like groups helped to train artists and
 maintain standards.
Artists addressed important individual and community factors
 framed around the life cycle (birth, initiation, marriage,
 health, death).

KEY QUESTION

In what ways do more recent African art traditions have a
 grounding in earlier traditions in these areas and elsewhere?

THE COLONIAL ERA
(1850–1959 CE)

-

**If you ask questions, you
cannot avoid answers**

-

Cameroon proverb

The gathering storm clouds of European military intervention in Africa and the onset of a new colonial era became clearly visible in the mid-to-late 19th century, culminating in changes across the continent between 1890 and 1910. An exception was Ethiopian Negus Menelik II, whose 1896 defeat of Italian troops at Adwa preserved his nation from broader European colonialization efforts until the Italo-Ethiopian War of 1935–6 and following this period. The 'Scramble for Africa' took root at the influential 1884–5 Berlin Conference, assembling many European leaders to decide how Africa would be divided into separate colonial states. The powers gathered in this meeting proposed a deep division with notable impacts for both the African peoples (without their consent) and their colonizers. British-Nigerian artist Yinka Shonibare imagined this scene as a sculptural rendering featuring diversely attired Europeans seated around a large table, in animated discussion about the map of Africa on the table's surface, each part demarcated by a different hue; Europeans here were only concerned about their own benefits from such a division, oblivious to further harm perpetuated on African peoples and their institutions.

New missionizing efforts followed on the heels of centuries-long financial engagement through conversion efforts, the slave trade and other trade. The violence and horror wrought by the European-led Atlantic slave trade had reached crisis point, and even with the official end of British involvement in 1807, the trade in enslaved Africans to the Americas and elsewhere continued until the 1860s. New obligatory commercial trade agreements between the various colonial powers and an end to slave-trade-linked warfare that only a few decades earlier Europeans had flamed and funded came into play. With the 1890 Brussels Conference enacting anti-slavery measures for European powers and the United States (though practices would linger through the 1930s and '40s in the context of contract labour), new issues, economies and exploitative, violence-enhanced relationships emerged.

African artists and art patrons engaged with the turbulent colonial time in varied ways. Some local art patrons commissioned works that were employed in colonial wars themselves. A stunning Dahomey (Fon, Republic of Benin) iron warrior sculpture (opposite) travelled to the battlefield against French colonial forces in coastal Ouidah during the 1892–3 campaign. It was then shipped to France as military war booty and gifted to the Musée d'Ethnographie du Trocadéro in Paris by Captain Fonssagrives in 1894. This sculpture was then returned by France to its homeland, along with several other art works (including page 132), in 2021. In 1897, a few years

Akpele Kendo Akati
War god Gu figure
Dahomey, Republic
of Benin, c.1860
Iron, 178.5 x 53 x 60 cm
(70⅜ x 20⅞ x 23⅝ in.)
Formerly Pavillon des
Sessions, Musée du
Louvre, Paris. Repatriated
to Republic of Benin

The talented sculptor, a
Gu devotee (like all local
blacksmiths and artists),
designed and assembled
the work from local and
European iron elements.
This construction reflects
the ongoing back-
and-forth engagement
between Africa and
Europe in this and
preceding eras. Picasso
drew on this work for
inspiration in developing
Cubism when it was in
the Trocadéro Museum.

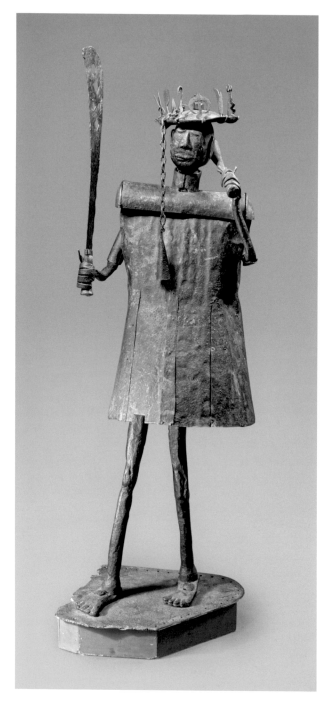

Sossa Dede
Dahomey *bocio* royal
figure honouring King
Glele (r.1858–1889)
Dahomey, Republic of
Benin, 19th century
Wood, 179 x 77 x 110 cm
(70½ x 30⅜ x 43⅜ in.)
Formerly Musée du quai
Branly – Jacques Chirac,
Paris. Repatriated to
Republic of Benin

**This work's unusual
contrapposto posture
and heraldic raised-arm
gesture are modelled
on life-size French saint
figures commissioned
by Glele's father, King
Guezo, who was interested
in accessing European
religious power. Despite
the unusual imagery
source, this is a unique,
boldly localized African
sculpture, a brilliant
reimagination akin to
Picasso's engagement
with African art.**

after the French–Dahomey colonial wars, the British invaded
the Edo/Benin Kingdom and took away as war booty many of the
famous Benin bronzes and ivories that, like a number of Dahomey
royal works, are currently part of repatriation efforts.

The work shown has a long history linked to Dahomey military
efforts. The artist, talented blacksmith Akpele Kendo (Ekplekendo)
Akati, was himself a war prisoner, captured in a Mahi community
north of Abomey, the Fon capital, then assigned to work in a local
smithing compound. His blacksmithing skill saved him from being
sent into slavery in the Americas. Referred to as *agojie* ('watch out
above') – the same name as the kingdom's famed female warriors –
this sculpture empowered by the war and creativity god Gu featured
in local battles, purportedly yelling 'watch out' whenever danger
was near. The sculpture's gnarled hands, one holding a large *gubasa*
sword, are shown in battle stance, ready to attack. He wears a crown
encircled with miniature weapons, tools and other iron ritual forms

consistent with Gu, the technology and iron patron deity. Similar iron elements are included in Gu shrines.

This stunning work was commissioned by one of Dahomey's most bellicose kings, Glele (r.1858–1889), to honour his war-supporting father, King Guezo (Ghezo, Gezo r.1818–1858), under whose rule this artist was captured. King Glele's praise name (Basagla ji Guhonlon madon, 'the great *gubasa* sword gave birth to Gu and he will carry out the vengeance'), delimited in his Ifa divination sign, is directly evoked in the sculpture through the sword held in its hands, suggesting that King Glele was born to a powerful individual and now continues his father's military aggression.

A very different colonial-era example is a life-size zoomorphic wood carving – a lion-man (opposite) created by artist Sossa Dede, whose family may have been war prisoners during the reign of Agonglo (1789–1797). This work honours the memory of King Glele. His avatar was a lion, based in part on another of his praise names and divination sign, Kini Kini Kini ('lion of lions'). Royal power sculptures (*bo*; *bocio*) helped promote military victories for kings like Glele and those associated with them. This lion-man and similar life-size royal carvings were wheeled on wagons in the capital during annual ceremonies honouring past rulers. They were also taken to war.

Lion imagery became popular in West Africa in late 19th-century art works that drew on European heraldic imagery. Otherwise the lion is rarely portrayed in African art; leopards predominate.

Some Kongo works bristle with energy (overleaf), their prickly surfaces studded with nails and other iron pieces. Known as Nkisi-Nkonde, this sculpture addresses jurisprudence as linked to the roles of rulers, as seen here in the royal cap-form crown. Larger works of this type were also employed to keep colonial-era harm at bay. These sculptures were created through an accumulative process, a ritual specialist (Nganga) embedding *bilongo* medicines (assembled from animal or plant ashes along with mineral sources) within the belly's interior vessel to enhance its power. The mirrored belly surface and eyes draw viewers into the work, while also linking it to the watery ancestral world. Nails inserted into the figure's 'flesh' may reflect the long Christian legacy and the roles that crucifixes and related religious objects assumed.

In the colonial period these works came to be reframed in the West as symbols of the purported irrationality of local beliefs and customs

Kongo artist
Kongo Nkisi-Nkonde
figure
Democratic Republic
of Congo, 19th–early
20th century
Wood, iron, cloth,
mirror, leopard tooth,
fibre and porcelain,
45.7 x 20.3 x 8.9 cm
(18 x 8 x 3½ in.)
Yale University Art
Gallery, New Haven

**This work's power is
enhanced by iron nails
and small pieces of
cloth or skin, each
of which marks a specific
event (an adjudication,
treaty, vow, promise
made or illness healed).
These underscore
community agreements
(laws – deterring
future problems), while
potentially punishing
those who break Nkisi-
Nkonde agreements.**

In the colonial era, African artists also took up new kinds of
work. In Congo they sometimes created lively tableaux featuring
European visitors (opposite), depicting their strange dress forms
and features, as well as crucifixion scenes seen in European
missionary efforts, already several centuries old. Kongo artists
showed great skill in carving ivory tusks, a material now in great
foreign demand for piano keys and combs. Well-funded 'scientific'
collecting missions (by Western institutions) brought sweeping
devastation to core arts and fauna, denuding whole areas of their
rich artistic and environmental heritage. In the Mangbetu Kingdom,
entire collections of art as well as royal hair coiffures, nails and
handsome musical instruments were packed up and carried by
porters to waiting ships for later cataloguing, study and partial
display in the West. One Mangbetu figural profile and coiffure
became a prized French colonial emblem.

The colonial period also saw the creation of art works honouring
culture heroes of the past, such as Tchibinda (Chibinda) Ilunga,
the brother of a Luba king, who married a powerful Lunda woman
from the south and became the founder of the Chokwe Kingdom.

Kongo ivory carver
Kongo receptacle
and cover
Democratic Republic
of Congo, 1880–90
Ivory, 17.1 x 5.1 x 5.7 cm
(6¾ x 2 x 2¼ in.)
Metropolitan Museum
of Art, New York

The attention to
physiognomy, coiffure
and objects (keys,
rifles, birds) shows how
astutely observant these
artists were. Kongo
artists visually clarified
differences between
scenes of ritual, daily
life and status (generally
people shown wearing
shoes often portray
Europeans or Kongolese
closely associated
with them). Christ's
attendants are shown
barefoot.

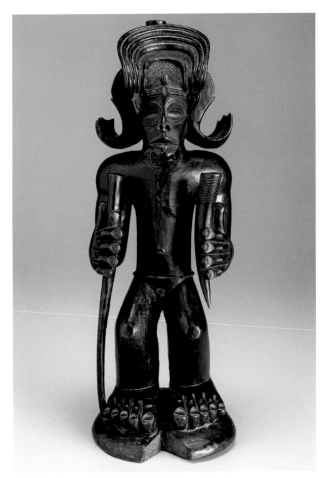

Chokwe wood carver
Chokwe figure of culture
hero Tchibinda Ilunga
Angola, mid-19th century
Wood, hair and hide,
40.6 x 15.2 x 15.2 cm
(16 x 6 x 6 in.)
Kimbell Art Museum,
Fort Worth

**Luba's founder was a
great hunter. He holds
a carved antelope horn in
his left hand and a staff
in his right. His physical
strength, fixed eyes,
clenched mouth and
bent knees suggest power
and readiness for action.
Royal status is demarked
by his coiffure's broad
rolled side elements.**

Tchibinda Ilunga and his legacy are memorialized in striking period
carvings (above). In the colonial era, the Chokwe swept up the
modern Angola/northwest Zambia region into an expanding
Lunda Empire. The kingdom doubled in size between the late 17th
and 19th centuries, covering some 300,000 square kilometres
(115,000 square miles) thanks to firearm access and coast-to-coast
trade of ivory, wax, rubber and humans. Chokwe chiefs retained
local ritual power through this period, sometimes being employed
as Lunda soldiers and hunters, though their independence and
chiefly authority had diminished.

 A Chokwe chief's throne (*ngundja* – opposite) speaks to the ways
in which European art forms, including chairs, were appropriated
and transformed by local African artists and patrons as status

objects. Along the top rung are two long-beaked birds (*ngungu*), a large species identified with chiefly power and good fortune, recalling the mediation of earthly and spiritual worlds as well as origin myths about how this bird led to selecting the first Chokwe royal capital site. The row beneath this includes scenes of *cikunza* maskers, and beneath this, imagery like circumcision and childbirth. On the struts below are references to quotidian life – men working in the fields and herding cattle, women cooking and caring for children – all suggesting a well-organized and functioning society.

One especially transformative leader during the colonial era was King Ibrahim Mbouombouo Njoya (1860–c.1933), a remarkable ruler and art patron from Foumbam, Bamun's royal capital in what is today Cameroon. Njoya faced a twofold incursion. One came from the expanding Hausa state situated to the northwest in what is now northern Nigeria. The other was colonists. With the

Chokwe wood carver
Chokwe chief's
ngundja chair
Angola,
19th–20th century
Wood, brass
tacks and leather,
99.1 x 43.2 x 61.6 cm
(39 x 17 x 24¼ in.)
Metropolitan Museum
of Art, New York

Chiefly chairs such as this highlight how local and colonial symbolism were joined. While the form itself, along with the decorative rows of tacks, is European, the chair back shows imagery from chieftaincy to religious life.

arrival of German colonizers and missionaries, Njoya converted to
Christianity, then, in 1916 to Islam, when Bamun became a partial
tribute state to the Hausa Sokoto Caliphate (northern Nigeria), one
of the region's major pre-colonial military powers and enslavement
states. Njoya had advanced vital textile manufacturing interests with
Sokoto, perhaps sparing Bamun from Hausa expansionist interests.
A man of unique talent, Njoya helped to document and preserve
Bamun art, culture and history, including the introduction of a new
written script (using seventy-three distinct signs), in handsome
ink-and-pencil drawings that speak to his remarkable observational
skills and unique style (above). Here we see King Njoya enthroned
before the portal to his new palace (which his nephew artist Ibrahim
Njoya designed). In the scene below, the new script is applied to a
large cloth and presented to local elders. Four core Bamun activities
are shown on each side of King Njoya – hunting, court hearings,
agriculture and music. Around the periphery is an array of Bamun
textile and other design motifs. In the central scene, King Njoya is
holding court, seated on a massive throne that features, among other
motifs, double serpent emblematic imagery of several Grasslands

Ibrahim Njoya
Portraits des 18 rois bamun
(Illustrated king list with
eighteen rulers, detail)
Bamun, Cameroon,
1938–40
Ink and colour
pencil, 77 x 83 cm
(30⅜ x 32¾ in.)
Musée Royal de
Foumban, Palais
de Foumban

**Positioned around
King Njoya are his royal
predecessors. One reads
the image from the
centre to the lower left,
then clockwise. This is
also how one reads carved
palace door frames.**

kingdoms, and a line of earth spiders – symbolizing local divination practices. Like other Bamun kings, Njoya held daily morning court sessions when individuals met to address problems.

Njoya continued to work with German colonizers, who granted Bamun relative independence. His friendship with Germany was sealed when, early in his reign, they aided him in retrieving the skull of his father, Nsangu, who had died in an 1886–7 battle against the Nso people. Bamun enthronement rites required a new king to pledge on the preceding ruler's head. In honour of Kaiser Wilhelm II's birthday in 1908, Njoya gave him a copy of his throne (placed on view in Berlin); in turn, Wilhelm II gave his own portrait and a German Imperial Guard uniform – now on display in the Bamun Palace Museum. Njoya commissioned local tailors to fashion new court uniforms on this model. With the 1916 French takeover of Cameroon, he commissioned a new palace modelled on both Hausa and German prototypes, using locally made bricks and tiles to replace the traditional sculpted wooden posts and thatched roofs of earlier palaces.

Elsewhere, African communities sought to grapple with larger colonial impacts, using art and diverse religious idioms in these expressions. One particularly important example is the *mbari* sculpture-rich earthen structures (below) created by the Igbo

Igbo community
Mbari house
Detail showing the Earth Goddess Ala and the Thunder God Amadioha
Nigeria, 1950s

The structures are made as a gift, sacrifice and dedication to the Earth Goddess Ala and other gods, key among these Amadioha, the Thunder God, co-joining powers of earth and sky. This work also celebrates Ala's nurturing associations (as mother of humans) and Amadioha's fertilizing rain.

of southeastern Nigeria. These forms came into prominence
in the first five decades of the 20th century. The structures,
some with nearly a hundred sculptures, took one to two years to
complete through a ritual process involving the larger community
in a performance-linked architectural and sculptural art form.
These tableaux are made from termite-mound earth, which,
once pounded, resembles clay. The *mbari* structures themselves
often show diverse figural compositions – animals, ancestors,
mythical creatures and humans (midwives, teachers, craftsmen
and foreigners). In this work, we also see how new colonial realities
are in play. The Earth Goddess Ala wears an elaborate coiffure,
multiple anklets and body painting patterns applied by Igbo women
in marriage preparation rites. The Thunder God, Amadioha, holds
a titled man's spear and wears colonial attire – a pith helmet, white
shirt with pocket, necktie, shorts, long socks and shoes. If his wife
Ala represents the ongoing values of the past, her partner evokes
counterbalancing exigencies and future realities. The word *mbari*
itself signifies museum. Once the *mbari* house is completed, this
unique ritual and performance art piece is allowed to melt back into
the earth without repair or maintenance, re-fertilizing the earth.

Yoruba artist Olowe of Ise (1869–1938) worked in colonial-
era Nigeria, when British government officials furnished funds for
local rulers to help stabilize the region after the slave-trade-era
ravishment. His commissions were often linked to both royalty and
religion. Many Yoruba kings restored or rebuilt palaces during this
period, hiring artists such as Olowe, whose sculptures featured at
Ekiti's Ikere Palace. One such sculpture (opposite) portrays a ruler
on a European chair-style throne, wearing the distinctive bird-
surmounted royal Yoruba conical beaded crown. In front kneels
a wife (his queen?). Another important figure is the messenger
deity Eshu, whose face appears at the top of every Yoruba and Fon
divination board. The king's large, beaded crown speaks to medieval
Ife's legacy as a glass bead manufacturing centre, from which Yoruba
rulership legitimacy is still bestowed and where, today, many Yoruba
crowns continue to be made; the beads originally were fashioned at
Ife's Olokun site. The queen mother in this carving wears Olokun's
colour (light blue). The Yoruba god of plenty, large water bodies,
trade and fertility, Olokun enriches both the king and his city-state
through her beads.

The bird atop this crown references the tiny rare migrating
okin bird whose tail feathers grow during mating season. Birds also
evoke sorcery, indicating at once a ruler's powers to harness natural
forces for protective ends and to counter sorcerers. The faces at

Olowe of Ise
Ikere Yoruba Palace
veranda post showing
King (Oba) and his family
Nigeria, 1910–14
Wood and pigment,
152.5 x 31.8 x 40.6 cm
(60 x 12½ x 16 in.)
Art Institute of Chicago

**Behind the king stands
his mother, physically
dominating this scene
as queen mothers did
in life. She becomes a
caryatid figure (bearing
the veranda beam on her
head). Her tall coiffure
is a notably elaborate
one, as befits a queen
mother. She holds the
back of the ruler's chair,
indicating that it was
her efforts that brought
him this position.**

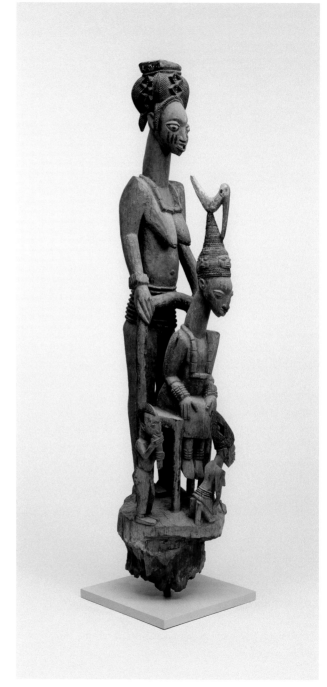

Lagos-based Luso-Yoruba architect
Ebun house owned by Andrew W. U. Thomas, built in Luso-African style Lagos, Nigeria, early 20th century Photograph by photographer and anthropologist Pierre Verger (1902–1996)

Luso-African Baroque architecture (residences, religious buildings and other structures) required skilled carpenters, new tools and cement artists. Local architects (some returned formerly enslaved individuals) transformed the exuberant volumetric style into extraordinary sculptural statements.

the crown's front and sides (sometimes only on the front) honours the kingdom's founding ancestor. These crowns historically had beaded veils obscuring the ruler's face. Sometimes doubled triangles decorate the surface, signalling the ruler's close association with Shango, the thunder and lightning deity. As protector of kings, Shango also controls the seasons (rain's arrival, crucial for life and farming) and safeguards one from theft (goods, people and benefits), since lightning constitutes punishment. The crown's secure fitting on this king's head reflects the tradition that if rulers look inside their crowns, where powerful medicines were placed, they could die.

This era also saw artistic forms of celebration by formerly enslaved African individuals. New exuberant architectural forms emerged, reflecting in part changes that came through European intervention. In Lagos, Nigeria, a largely Yoruba coastal city long inhabited by individuals fleeing wars fuelled by the slave trade in West and Central African coastal cities and those further inland, wealthy individuals constructed ornate Neo-Baroque Luso-African style buildings (above). The Neo-Baroque architectural tradition has a long history as a symbol of empire, extending from late 16th-century Italy to Portugal, Spain and the Americas (Brazil among other sites), flourishing through the late 18th century, then being reinvented on the West African coast (Nigeria, Republic of Benin

and elsewhere) when freed slaves returned to Africa. One of the most elaborate such buildings is the 1913 Ebun House in Lagos, the residence of a wealthy Oyo Yoruba prince and successful auctioneer named Andrew W. U. Thomas (1865–1924). In inland areas, this building style became fashionable not only for wealthy cocoa merchants but also for court ministers and chiefs. Pushing the core visual idioms of the Baroque to their technical and aesthetic limits with cement was a way of proclaiming one's freedom as Africans while also intentionally surpassing Europe in their own architectural styles. Preserving such structures today is important.

Another especially fine architectural example addresses the work of the same Boso (Bozo) culture of architects who rebuilt the stunning Djenne mosque. In this era, Boso builders completed beautiful men's initiation houses (called *saho*) along nearby Niger River banks (below). These were visible to Boso boatsmen and passengers who travelled up and downstream between Djenne and other centres. The name Boso is thought to derive from the nearby Bamana term for 'straw house' (*bo so*), in reference to their traditional homes. This suggests the Boso's role as indigenous builders, but also as architects of the Mali and French Colonial Empire here. Whereas Europeans were using cement for such structures in the Mali capital of Bamako and elsewhere, Boso

Boso architect/builders
Saho men's initiation house
Kolenzé, Mali,
20th century

This example, in Kolenzé, Mali, uses local earthen materials to fashion a European colonial-style building. It re-imagines the quasi-'tropical modernism' style, with its neo-classical columns, pilasters, arches and balustrades re-arranged in a multi-storey structure, with enough large and small openings for air circulation in hot climates.

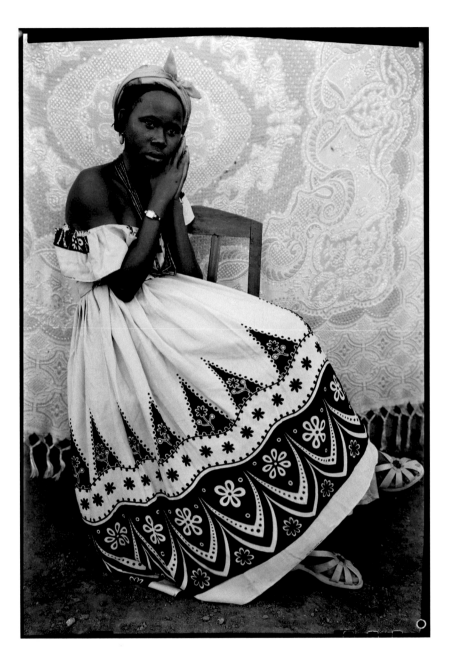

Seydou Keïta
Untitled
Mali, 1948–54
Gelatin silver print

The young woman shown here, with an expensive watch, sandals and headdress, is featured within a swirl of rich background lace patterning and an almost Baroque outward-fanning flower with petals that make the rich hues and textures compelling.

architects added more complex detailing, achieving this with earth. While these structures indicate a celebration of colonial forms, they also display a sense of pride in achieving them in a more technically difficult way.

As the move towards African independence took root in 1945–60, artists turned to imagining and creating new local worlds with an eye and ear for modernization. One of these talented artists, Seydou Keïta of Mali (1921/3–2001), chose photographic portraiture as his main medium (opposite). Born to a local family of carpenters working in Bamako, he took up photography after an uncle brought him a Kodak Brownie camera from Senegal in 1935. By 1948 Keïta had a large enough portraiture clientele to acquire his first studio. This was a period of relative well-being in Mali. Urban or rural residents (the latter coming to the studio post-harvest) are depicted with unique style and vitality. The photo shown here is from Keïta's early period and is a bold example of his richly stylized black and white compositions. He saved all his black and white negatives (some 7,000–30,000 over his career) and these convey the unique collaboration of the photographer (who furnished clothing, props and backdrops) working with the client to select the best identifying elements. In 1962, after Mali's independence, Keïta became the official government photographer, and a year later he closed his studio. His work first received attention in the West as an anonymous photograph displayed in the 1991 exhibition 'Africa Explores' at the Center for African Art, New York City.

KEY IDEAS

During the colonial era African artists and patrons played vital military and diplomatic roles.

European colonial practices brought hardship to some areas, while others benefitted.

New kinds of patronage and new goods or materials were put to use.

Colonial activities continue to impact exhibition and collecting practices although historic artistic practices in this period remain valued.

KEY QUESTION

In what ways will the response to colonial activities and other global issues reshape African art research and exhibition strategies in the near future?

CONTEMPORARY ART:
A NEW GOLDEN AGE
(1960 TO THE PRESENT)

-

Time and tide wait for nobody

-

Igbo proverb

Freddy Tsimba
Corps en mutation
(*Mutating Bodies*), 2006
Brass, leather and
other materials,
202 x 106 x 54 cm
(79⅝ x 41¾ x 21⅜ in.)
Installation at
Dak'Art, 2006

Corps en mutation
speaks to the vast scale
of colonial violence that
persisted through the
Mobotu dictatorship
and continues to
this day due to the
international mining
drive for diamonds,
copper and rare trace
minerals powering cell
phones, laptops and
similar devices. The
work is fashioned from
bullet shell casings and
old military boots, from
the literal minefield of
present and past.

The exuberance of the 1960s rush to independence ushered in an
important period of African artistic production – a 'new golden age'
not only of African art but of global engagement with contemporary
African works. This revitalization has been fostered and enriched
by numerous forces. Among these are global exhibition platforms
such as documenta (founded in 1955, with circulating sites every
five years), Festac '77 (also known as the Second World Black
and African Festival of Arts and Culture – in Lagos, Nigeria) and
Dak'Art (a biennale in Dakar, Senegal, its focus being on African
art from 1996). Contemporary African art has also benefitted from
a talented group of largely African-born art critics, led by Nigerian
curator Okwui Enwezor, who engaged with and celebrated the new
generation of artists in ways that challenged the status quo and
positioned African art within contemporary world art in visual and

theoretical terms. Moving outside the boundaries of both newly independent nation-state identities and the rich historical legacy of African artistic production, these artists reached new creative and financial success through public commissions both within and outside the continent. These works often take up the challenging legacies of African global history – the slave trade, colonialism, Apartheid, racism, gender, migration and the environment – in ways that not only manifest visual power and technical acumen but also re-engage the creative forces found in earlier African art eras.

The works in this chapter span new and older artistic media – sculpture, painting, drawing, photography, collage and installation art. They are both outward-looking and grounded in complex African histories from key vantage points across the continent. These artists are now part of a larger global contemporary art dynamic, often represented by top agents, exhibited by renowned museums and receiving important commissions. What distinguishes these African artists' works from others elsewhere? One factor is their power of form and sculptural primacy. Even these works of diverse media share a unique complexity, richness and sense of monumentality and power.

There is a ready playfulness that stands with and in contrast to the often deeply painful ideas expressed

Freddy Tsimba's (b.1967, Democratic Republic of Congo) installation *Corps en mutation* (*Mutating Bodies* – opposite), presented at the 2006 Dak'Art exhibition, addresses at once the present and past. The figure posed on the ground is exhausted by the war experiences, chaos and decay. This work also evokes the deeply painful legacy of Congo's brutal colonial past, where some 8–10 million people died between 1885 and 1908 under Belgian King Leopold II's violent rubber plantation and extraction efforts. A powerful assemblage work, it speaks to the earlier African roots of assemblage arts that were championed by Pablo Picasso in fashioning Cubism. The assembled parts create voids that speak to the impacts of war on individual lives and souls here and elsewhere. The work's spent bullet casings denote the spent lives of people who somehow must carry on despite past trauma or when death remains a constant presence.

The drawing and collage work *It Left Him Cold* (overleaf) by South African artist Sam Nhlengethwa (b.1955) addresses the 1977

murder of well-known anti-Apartheid activist Steve Biko, a member of the Black Consciousness Movement (BCM) who was killed by a police officer using a rubber hose during interrogations. Seized earlier that day (August 18, 1977) at a roadblock and jailed in Port Elizabeth for his political activities, Biko was later found naked and shackled outside a police hospital in Pretoria, some 740 miles away. Following Biko's death, he became a critical early icon of anti-Apartheid drives, a celebrated African political martyr. In Nhlengethwa's work, the stark cement floor is illuminated by light entering through the open door, through which we glimpse another person leaning forward in stunned response, and above him, a group of people in discussion. They and the taller buildings behind them, structures whose windows overlook the scene, may well have witnessed the violence.

On the irregularly laid brick and stone wall background, comprising drawn and cut details, hangs a colour portrait of an officer in a crisp blue shirt, tie and dark jacket, as if to mark approval of the death by both the highest government officials and western civilization more generally. In the foreground to the body's left is an assemblage of objects that stand as witnesses and crime evidence – a desk, two chairs (prisoner's and officer's), a pair of broken glasses, an officer's cap, a typewriter and an orange coffee mug. The use of

Sam Nhlengethwa
It Left Him Cold, 1990
Charcoal and colour
pencil drawing on paper,
69 x 93 cm
(27¼ x 36⅝ in.)
Wits Art Museum,
Johannesburg

Nhlengethwa's dark grey-brown palette serves as a poignant setting for the scene. Dominated by the deceased hero's naked bruised body, his face still riveted by pain, this is a jarringly hard-edged rendering emphasized by the increased scale of the head in relationship to the body, with torn-up collage effects enhancing the impact.

collage here conveys ideas of fissure and reconstitution, germane at both the social and individual level in speaking to how memory – and archives – seek a sense of the whole through partial and unequal memory fragments. This collage is also critical as a reference to roles South African artists played in bringing international attention to the Apartheid system's inherent violence and racism. The work was included in the 1995 London Whitechapel exhibition 'Seven Stories About Modern Art in Africa', which sought to explore African modernism, though still featuring colonial-nation framing.

Ousmane Sembène's *Black Girl* (below) is a uniquely important film, not only the first major film by an African filmmaker, but also a work that, though fiction, reveals much about African lives in the post-colonial era. Sembène (1923–2007) was a prizewinning artist who did not shy away from painful and controversial themes, addressing female genital mutilation in his 2004 film *Moolaadé*. This still from *Black Girl*, titled in French *La noire de...* (*Black Girl/ Woman from/of...*), Sembène's first feature film, focuses on a young Senegalese woman, Diouana, who moves from Dakar to France to work as a nanny, but instead is forced to become a servant, imprisoned within her employers' affluent home. The personal impacts of colonialism, racism and painful slavery legacies are examined here, in a context familiar to many Africans who have sought work outside the continent as local economic viability has diminished. Diouana's new European attire contrasts markedly with the richly coloured and patterned textile fashions worn by

Ousmane Sembène
Still from *Black Girl*
(*La noire de...*), 1966
French-Senegalese film

Diouana's gift to the couple of an African mask, an art form recalling modern works sold in Dakar's tourist-focused galleries, is a key film 'character', referencing not only her homeland and culture, but also how far her life and well-being have fallen as slowly the heroine's core identity is stripped from her.

many Senegalese and other African residents. The African mask on the couple's wall is a shadowy icon of both past lives and how things have changed for many Africans since the colonial takeover. The specific mask type is of recent vintage, a type carved often specifically for expatriates, this one perhaps based on Mali mask exemplars.

Republic of Benin artist Meschac Gaba (b.1961) created a global city scale-model for the 2006 São Paulo Biennial, which had as its theme 'how we live together' (above). Made from sugar and framed loosely around the Brazilian city of Recife, where Gaba undertook an earlier residency, *Sweetness* speaks to global urban development models where ideals too often circumvent and even counter individual residents' needs. Brazil was a leading sugar producer from the 17th century onwards and the industry relied on enslaved Africans to harvest sugar cane used to make sugar and its derivatives, notably rum and other liquors. The tiny sugar cubes (bricks), often more readily available in Republic of Benin than gasoline (oil) required for transportation and electricity, also address the troubling modern economic situation. This work is not just about violence and past deeds, but ongoing legacies of Africa's exploitation (for minerals, water, land, exploitative currency standards, proprietary loans, scientific study and armament sales) in the face of devastating issues like climate change, racial justice and profound socio-economic divisions.

Meschac Gaba
Sweetness, 2006
Sugar, 9 x 5.5 m
(29 ft 8¾ in. x 17 ft 11¾ in.)
Installation, Bienal de São Paulo, 2006

The use of sugar to create this elegant architectural model addresses the legacy of the triangular trade and points to the hard-edged realities of Euro-American desire, recalling Leopold II's eagerness to get a slice of the 'magnificent African cake'.

El Anatsui
Gravity and Grace, 2010
Aluminium and copper
wire, 4.8 x 11.2 m
(15 ft 10⅛ in. x 36 ft 9 in.)
Virginia Museum of
Fine Arts, Richmond

Created by a large
studio of assistants,
each textured tableau
becomes a patchwork
quilt on a selected theme.
Light shimmies across
the richly coloured
undulating surface,
animating details and
shadows. Curators who
hang these works are part
of the creative design
process, as each tableau
can be hung multiple
ways, transforming
its visual impact with
each engagement.

**Pleasure (sweetness), beauty and future development
come at a steep price**

El Anatsui's (b.1944) shimmering metal tapestry *Gravity and
Grace* (above) is assembled with aluminium caps from liquor, and
other bottle caps. This work by the native Ghanaian artist, long active
in Nigeria, is simultaneously a monumental textile and sculptural art
form. Its construction evokes body-moving and vibrantly coloured
Ghanaian Kente textile arts. The composition is determined through
a collaborative design process, and the work is created through a
labour-intensive process of flattening, perforating and assembling
the caps with multiple copper wires. Like Meschac Gaba, El Anatsui
addresses difficult histories and legacies of the slave trade and
alcohol's role in it. Because metal liquor and other bottle caps – like
other refuse – often fill local rubbish heaps, this tapestry sculpture
also speaks to issues of recycling and the environment.

Sammy Baloji's (b.1978) large-format colour photographic
montage of industrial and war-torn Congo (overleaf), part of his
2006 series 'Mémoire' (Memory), uses archival images of Congolese
labourers during the colonial era superimposed on the artist's own
photographs taken in the Lubumbashi Katanga mining area of his
birth. The juxtaposition of the nearly monochromatic background

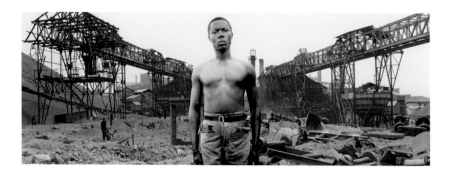

with the polychrome details of the two figures highlights temporal changes. The black and white foreground miner's torn trousers and cinched belt speak to the difficulty of a miner's life. The work's collage-like rupture and suture thematically underscore this visual montage of past, present, future and ongoing time. The 'Mémoire' assemblage image draws our attention to an earlier period of richness and industry now silenced, and a deeply contested terrain in the predatory global capitalistic drivers that succeeded exploitative colonial-era practices, both negatively impacting livability, sustainability and well-being.

Tunisian artist B'chira Triki Bouazizi (b.1964) plays a vital role as both art maker and art patron. Her works (opposite) include installations, paintings on canvas and ceramics that speak to questions of materials (gold and others), Arabic calligraphy and the dynamics of veiling, through rich and elegant engagements with both form and movement. Cloth covering (veils) and ideas of separation and communication, transparency and grounding come into play. Gold, a core element of the trans-Saharan trade, often features prominently. After the 2011 revolution, Bouazizi initiated work to support young artists, creating workshops, studios and a gallery space where they could exhibit their work.

South African photographer Zanele Muholi (b.1972) creates impactful self-portraits with unique power and engagement. This self-portrait series titled 'Somnyama Ngonyama (Hail, Dark Lioness)' (page 156) addresses complex ideas of identity, fashion and re-engagement. Individually and together the photographs constitute a form of visual activism that speaks directly to homophobia and race hatred, two of Muholi's key concerns. After training in a Johannesburg workshop founded by South African photographer David Goldblatt, one of many White and Black South African artists who helped create the photographic archive that recorded and protested against Apartheid, Muholi co-founded

Sammy Baloji
Untitled 17, from the series 'Mémoire', 2006
Archival digital photograph on satin matte paper

Piecing two perspectives of the same landscape together into one highlights not only differing viewpoints within the work but also the breaks and scars that remain part of the colonial-era heritage and the corruption-encumbered government's ongoing mining history.

B'chira Triki Bouazizi
Le voile du silence
(*The Veil of Silence*)
Installation, 2014

**This work addresses
Bouazizi's interest in
women and men in North
Africa and elsewhere,
redressing issues around
the exterior veiling of
one's identity or interior.
She couples these ideas
with veiling and unveiling
in a way that also
re-engages women and
women's bodies and the
strictures of a world that
may be closed to them.**

several empowerment and advocacy groups for women, homosexual and trans communities.

Focusing on the artist's own body as subject, Muholi refashions themself with various sometimes mundane materials – scouring (brillo) pads in this example, a form that addresses not only the history of Black women and service work, but also the long history of skin whitener being sold in Black communities. The directness with which Muholi stares at the camera, without expression, makes these portraits into vibrant archetypes, each enhanced by how Muholi addresses the artist's own smooth, dark skin, evoking fashion photography practices while also challenging longstanding beauty norms that create self-hatred. Like the roars of a lion evoked by the series title, beauty and power of expression come together to explore desire and danger in ways that evoke longstanding stigma and prejudice around queer identity in Africa and across the world.

Pritzker Prize-winning Burkina Faso architect Francis Kéré (b.1965) is an activist creator, sometimes engaging the whole community in the design and building of his stunning structures. Many of his architectural projects are in Africa, notably his native country and nearby Mali, but some are now found in Europe, the USA and Asia. The first person from his village to attend school, Kéré worked as a carpenter before studying architecture. His Opera Villages (page 157) incorporate an original African-style classicism that is both contemporary and timeless. Large overhanging roofs protect the walls from the sun's heat and from penetrating rain.

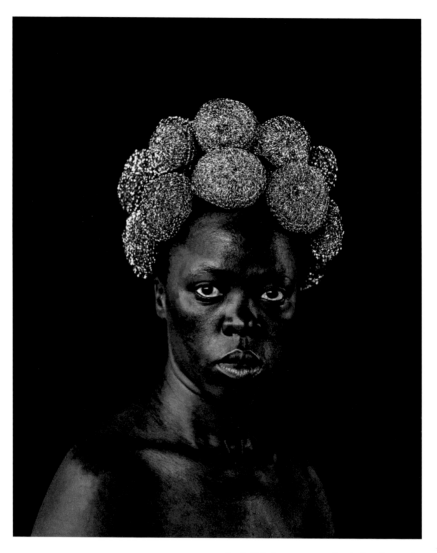

Zanele Muholi
Bester V, Mayotte, 2015
Silver gelatin print,
image size: 50 x 41 cm
(19¾ x 16¼ in.),
paper size: 60 x 51 cm
(23⅝ x 20⅛ in.).
Edition of 8 + 2

Seemingly ordinary attire
that Muholi uses includes
clothes pins, large safety
pins, cable ties, tyres
and electric wires. These
encircle the head and
body, evoking slavery,
repression, violence
and discrimination.
Brillo pads suggest skin
whitening practices –
subverting beauty.

Francis Kéré
Opera Villages,
begun 2010
Ouagadougou,
Burkina Faso

**Kéré creates his
structures from building
blocks; often his African
works incorporate earth,
recalling other historic
area architectural
forms. In this project,
primary core and
contrasting geometries
are re-engaged through
bold asymmetries,
celebrating the natural
warm earth tones and
rich, contrasting textures
of local and imported
materials.**

This 12-hectare (30-acre) housing development for local residents
is being built in stages near Burkina Faso's capital, Ouagadougou.
It features a school, theatre, medical centre, workshops, homes
and residences for guests – all built as basic modules, around a larger
spiral plan that naturally promotes ideas of growth and possibility.
Kéré's Centre for Earth Architecture in Mopti, Mali, provides
knowledge and support for new generations of African and other
architects to learn the potential of this form.

KEY IDEAS

African contemporary artists advance important ideas about
global events.

Ongoing issues around racism, Apartheid, enslavement and the
colonial legacy are important.

New media such as film and photography join older techniques
such as assemblage.

New exhibition contexts in Africa and elsewhere help to promote
these new arts.

KEY QUESTION

In what ways will African artists continue to lead and transform
the art world? How will their works be recognized and promoted
locally?

REFLECTIONS AND COMPARISONS

-

**The worlds of the elders do not lock
all the doors; they leave the right door open**

-

Zambian proverb

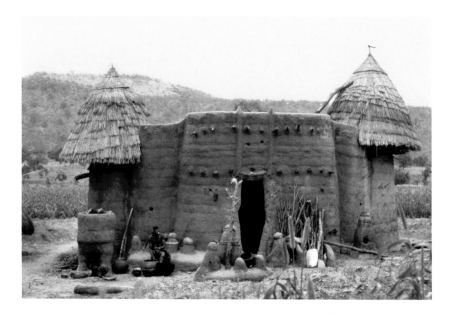

In this book we have addressed the history of African art, core
themes and regional events and factors. The African continent
is historically deep and so vast that it is hard to imagine how a
summary can do justice to the wealth and diversity of its arts.
Instead we conclude with a brief reflection on core examples that
individually or together help us to understand African art issues
more generally. Like the off-beat phrasing in jazz musical traditions,
African art frequently incorporates a rich play of visual elements
that work dynamically together.

In African architecture, stone, coral, earth and non-permanent
materials are widely used and often reflect both environmental and
communitarian interests. Straw roofs need regular rethatching and
earth requires yearly replastering, bringing families and communities
regularly together. Earth has the added advantage of keeping the
walls relatively warm in chillier night-time hours and relatively cool
during the day when the sun is at its hottest. These factors are
evidenced in the two-storey Batammaliba (Tamberma) houses in
Togo and the Republic of Benin (above), which display individuated,
lineage and community-based elements. Conical forms at the top
of the façade and in façade-adjacent shrines serve as resting places
and shelters for ancestor spirits, deities, enemies killed in battle and
animals felled in the hunt. The high god Liye/Kuiye is referenced
in the tallest portal-facing mound and in the west-facing entrance.
The Djenne mosque includes similarly shaped conical forms,

Koufitougou architect
Batammaliba house
Koufitougou, Togo,
20th century

**The Batammaliba
moved to this isolated
mountainous area to
avoid empire-building
efforts and Islamization.
Here, they created a
utopian model, with each
house being designed
by a master builder
and taking the same
basic shape (an ideal
five circle/oval form
enclosed with curving
walls), suggesting the
relative social equality of
this agricultural society
where elders play a key
governance role.**

conveying the legacy of past built environments. The Batammaliba are speakers of a Gur language related to Dogon. In both Dogon and Batammaliba contexts, houses and villages express human body symbolism. Batammaliba doors are the house mouth; the two raised corner granaries are the stomach. When the male house elder dies, the home is covered with textiles and the house is a focus of funeral rituals as if it were the deceased family member.

Seemingly ordinary or unusual forms in African contexts often have a place in art. In dynastic Egypt, dung beetles conveyed powerful and complex ideas in an especially creative way. The scarab bracelet (below) from Tutankhamun's (c.1341–c.1332 BCE) mortuary chamber highlights at once Africa's historic wealth (gold) and the use of unusual forms for cosmological themes, here the lowly dung beetle which, as noted previously, pushes large heavy egg-laden dung balls up-hill facing downwards and using its hind legs for traction. This and other works offer insight about the power of both the everyday and the unexpected in according value in life, religion and politics.

In widely different African settings, design strategies sometimes reveal deeper historically shared interests. Among the examples of such dynamism and diversity are modern Kuba raffia cut pile

Egyptian jewelry artist
Scarab bracelet from King Tutankhamun's tomb
Egypt, early 14th century BCE
Gold, stone and glass, diameter 6 cm (2⅜ in.)
Egyptian Museum, Cairo

One central issue in many works of African art is how seemingly rudimentary elements, like dung beetles, or widely dispersed artistic practices, like jewelry, carry deep meaning and importance to the whole community or area.

cloths (above) and an early medieval Nile Valley Coptic textile
(opposite). The Kuba, like the original Baka and other 'Pygmy'
groups, create bold, intersecting asymmetrical designs. For the
competitive Kuba art patrons, design dynamics are a major part
of individual expression and display strategies. These patterns are
worn not only as cloth wrappers but also as decorations on other
objects: dance regalia, drinking cups, cosmetics containers, musical
instruments, architecture and fencing. A mathematical study
of Kuba textile traditions found that a large majority of all known
design possibilities are employed by Kuba artists within their
raffia cut pile cloth patterns. Some Coptic textile examples,
including that shown here, display similar design complexity,
with contrasting geometric patterns.

In northern Nigeria the simple dome-shaped forms built by
nomadic Fulani pastoralists who herded cattle over the broad area
between Senegal and Nigeria were the inspiration for Hausa–Fulani
architects to design large dome-roofed palaces and mosques.
Many Fulani converted to Islam early, and in the first decades of
the 19th century were part of a powerful social revolution led by

Kuba weaver
Kuba textile
Democratic Republic
of Congo,
19th–20th century
Raffia, 73 x 60 cm
(28¾ x 23⅝ in.)
Brooklyn Museum,
New York

**Textiles are no less
important than
sculptures and other
art forms in Africa.
Kuba design patterns
have names deriving
from nature, culture
and history, referencing
knowledge sources within
this society and its art
historical legacy.**

Coptic weaver
Coptic textile
Wool and linen,
14.2 x 14 cm
(5⁹⁄₁₆ x 5½ in.)
Egypt, late 4th
century CE
Cooper Hewitt,
Smithsonian Design
Museum, New York

This kind of visual one-upmanship is not only a remarkable mathematical feat but also a strikingly creative one. Individually and together these forms show the vibrancy and visually engaging power of African textiles.

the Gobia (Hausa) Fulani cleric Usman dan Fodio. This movement overthrew local kings seen as living outside rigid religious principles and insisted on qualified court administrators – those knowledgeable in Arabic – from modern Nigeria to Mali. Some Fulani settled early into more permanent residences and cities. Local technological forms (a 'rudimentary' dome) can be seen in the no-longer extant palace of Mali's Emperor Mansa Musa (early 14th century). In the wealthy city of Djenne, Mali, rigid Fulani sect leaders later led to the destruction of the original Friday Mosque (see page 71); in Kano and other Fulani/Hausa Nigerian centres they created new architectures of empire featuring domes and elaborately decorated façades.

The palace dome of Kano's emir (overleaf, top), as befits a wealthy and powerful ruler, pulses with rich colours and patterns of other area arts. Each Hausa dome section is created from paired wooden supports that intersect at right angles. At each joint a multi-coloured plate is secured. The rib-vaulted substructure's core elements are stunningly painted with vibrant patterns. Small rectilinear windows provide light and add to the patterning as the sun moves across the sky, enhancing visual vibrancy. In contrast, the simplified black and

Muhammad Rumfa
Kano (Hausa) Palace
Dome interior
Nigeria, built 1470–99

**Hausa–Fulani domes
(atop a tall earthen wall
with wooden vaulting
supports) emerged in
large Hausa city-state
capitals such as Zaria
and Kano. These cities
were founded in the
Medieval period as
local populations were
converted to Islam.**

**Commissioned by Abd
ar-Rahman I**
Great Mosque dome
interior
Cordoba, Spain,
late 8th century

**This ribbed vaulting
dome technology is very
different from Roman
and Byzantine capstone
domes prevalent at the
time in Europe and the
Middle East. The Asiatic
Steppes nomadic dome
is similar, but unlike
African models is too
distant to have likely
factored in Muslim
Andalusia.**

white surfaces of the Zaria (Nigeria) Hausa domed Friday mosque interior emphasize religious purity and reverence.

Fulani-resembling dome rib-vaulting technology may have reached Europe through the Fulani-related Toucouleur in the Senegal River area where Almoravid Amazigh troops settled during the 11th century before advancing to Andalusia. In Andalusia, the African Muslim forces erected fortifications largely out of earth (for example, the outer walls of the Alhambra), preferring earth buildings, except for palace edifices, mosques, a few other structures and irrigation. Scholars now see the high quantity of Andalusian earthen structures as an African (Amazigh and other) influence. The choice of a rib-vaulted dome form rather than a Roman-style 'capstone' dome for the mosque at Cordoba (opposite, bottom) plausibly reflects this new African-linked sourcing. Built in the late 8th century, it complements Fulani dome forms, comprising an outer 'skin' set atop a vaulted structural core.

Historical ideas and cross-regional complementarities are important within the continent of Africa as well. Mummy-like sculptures are some of these forms. Among Bembe and Bwende Congo groups, living in the north of the Kongo Empire, family leaders were honoured with *muzidi* mannequins (overleaf) created prior to an elder's death. The body was later exhumed, and its relics added to the sculpture before the individual's memorial celebration, often positioned atop horizontal wooden supports in a procession. The sculpture is then transferred to the family's home as a lasting memorial. The raised and lowered hand gestures and embroidered design motifs address philosophical values about continuity, community and the connections between this world and the next – a kind of symbolic writing akin to Cross River *nsibidi*. Whether these and complementary Yoruba pseudo-mummies evoke late Nile Valley traditions is unclear, but reliquary-form family memorials are widely known local traditions. Each of these examples speaks to the deep-seated aesthetic and cultural value of the dead within the lives of the living, and the ways in which past, present and future continue to be engaged.

Among the Amazigh (Mauritania, Morocco, Algeria and Libya), textile and jewelry forms shared vital aesthetic and social interest. The beautiful miniature brass hand shapes within the headdress on page 167 stand out. Hand forms are a protective icon (amulet), particularly against 'evil eye' (sorcery), important also to other Muslim populations. Notable here specifically is the hand of Fatima, the daughter of the prophet Muhammed and his first wife Khadija. Colour is significant, with red evoking protection and strength,

Bembe Kongo artist
Bembe Kongo
niombo figure
Democratic Republic
of Congo, 19th–20th
century
Cloth and organic
materials, 58 x 50 cm
(22⅞ x 19¾ in.)
Museum of Ethnography,
Stockholm

**These works, known
as *muzidi*, harness a
deceased person's spirit,
providing core links
between family founders
and living progeny. These
cloth-wrapped figures
received prayers for both
general and personal
issues such as health
and well-being. They
were employed for
divination consultations,
addressing family and
individual problems
needing resolution.**

yellow for eternity, while green suggests peace. Amazigh individuals
played a seminal role in the history of both Africa and southern
Europe (Sicily and southern Spain), as early shapers and promoters
of Islam and founders of the important African Fatimid Islamic
dynasty that dominated an empire in North Africa and subsequently
in the Middle East from 909 to 1171 CE. Their inclusive values for
other faiths (Judaism, Christianity and traditional beliefs) helped
fashion civilizations deeply interested in knowledge while also
creating rich and influential art and architectural works.

This hand-form jewelry also reveals how African forms often
take on multiple meanings. In many places in Africa, Judaism
(like Christianity and Islam) has remained important, as attested
in Amazigh interchange contexts, such as the Fatimid period of
Islamic rule in Egypt, North Africa and Spain. This legacy continued
with Jewish temples and cemeteries (in Fez, Morocco, for example),
as well as in jewelry and other decorative arts. Many North African
Jewish women wear similar hand-form amulets (Hamsa/Khamsa) as
protection, the symbolism based on the Hebrew cognate *hamishah*

which also means five, here conveyed by five fingers. Like many African art forms, this motif can be read and understood on multiple levels and by sometimes quite different audiences.

Despite longstanding perceptions that Africa and its arts were somehow isolated from the rest of the world, addressing African art forms through a broader chronological and cross-cultural framework provides us with a very different view. We have sought in this small volume to counter longstanding myths and misunderstandings. With the rise of theories of development and difference in the so-called Age of Enlightenment, too often Africa has been dismissed as lacking key human values, established religious beliefs or rich artistic practices. Not only did African cultures develop their own unique writing systems, they also employed wheels (for arts, thread spinning and sometimes pottery) and retained and celebrated their histories, religions and political systems through an array of complex arts. In some cases, African groups colonized other places; global events such as the devastating Black Death also impacted Africa. Trade in goods, technological developments and trans-Atlantic slavery all left their mark, though art and culture here continued to thrive, offering evidence of how these events were being shaped locally. This brief history of African art offers vital evidence that creativity, innovation, invention, and ongoing change and development, both internally and related to other global arenas, have long been a force.

Amazigh woman at Douz festival wearing 'Hand of Fatima' jewelry Douz, Tunisia, 2000

The context in which this woman appears, an international Sahara festival in Douz, Tunisia, was established in 1910 and includes not only competitions between various Saharan horse and camel riders, but also discussions of potential marriages. Similar to new art celebrations like Dak'Art (Senegal), Douz events bring international visitors to this area.

GLOSSARY

Amazigh: important North African and Sahara population, once referred to as Berber.

Ancient Art: a term here used to designate the earliest African art works (to c.1000).

Anthropomorphism: the attribution of human characteristics to other forms, such as animals or buildings.

Apartheid: the system of government that imposed racial segregation in South Africa.

Art: visual and other cultural forms created for various reasons that are appreciated for their design, intellectual engagement, skillfulness, beauty, utilitarian value or power of expression.

Benin: refers either to the Edo Kingdom in southern Nigeria or the nearby modern nation state, the Republic of Benin.

Bes: Egyptian deity of music, household protection and childbirth, often depicted with a squat body, large head, wide ears and extending tongue.

Colonialism: the late 19th-century to early 20th-century period of European political and economic control over most of Africa.

Congo vs Kongo: the former refers to two central African countries (the Democratic Republic of Congo and the Republic of Congo); the latter designates the kingdom that once dominated this region.

Coptic: the historic and ongoing practice of Christianity in Egypt and Nubia, sometimes called Byzantine Africa.

Cosmology: beliefs about the heavens, time and the changing of the seasons.

Divination: the ritually linked practice for determining the reasons for particular events and how to mitigate harm.

Early Modern: the period between the Middle Ages and the Industrial Age, dominated by global exploration and Western expansion for commercial and political interests.

Enlightenment: Early Modern period intellectual movement that sought to endorse European 'reason' and 'scientific evidence' and introduced key lasting tenets that validated enslavement and racism.

Ghana vs Ghana: Medieval Ghana was near the Senegal headwaters; modern Ghana is on Africa's Atlantic coast.

Gorgon: dangerous sibling(s) of Medusa in Greek mythology, shown often in this and later periods with snake-form hair, fangs and an extended tongue.

Lost-wax casting: the method of casting brass, bronze or other copper alloys in which the clay core's surface is covered with wax and more clay. The liquid wax is removed once heated and this vacuum replaced by molten metal.

Mali: refers to both the medieval empire in the Middle Niger area and the modern country that covers a key part of this early empire.

Manuscript: a papyrus, parchment or paper document featuring text and/or imagery.

Medieval: a period of considerable local and international trade, between the Ancient and Early Modern eras.

Niger–Benue Confluence: the area of central Nigeria where the important Niger River and Benue Tributary merge. For part of the year the Benue waters enter waters connecting to a tributary of Lake Chad.

Nomadism: a societal and economic designation for populations who move regularly in the context of work: for herding, fishing and other needs.

Ochre: a red or yellow pigment from a stone whose powder is often used for body decoration cosmetics or textile colouring.

Ogboni: the Yoruba (Nigerian) association responsible for safe-guarding roads, judging and punishing crimes, selecting kings from designated candidates and keeping royals in check.

Pastoralism: the nomadic lifestyle and economy around herding cattle or sheep.

Pharaoh/Pharaonism: Ancient Egyptian monarch; description of later-era beliefs and medieval era or later artistic practices that draw on or revitalize earlier Egyptian political and religious art and architecture.

Repatriation: the return of art works wrongly removed from their original owners, often through acts of war.

Sahel: the very dry area on the southern fringes of the Sahara.

Savanna: a grassy plain, generally situated between forested and drier areas.

Shrine: a religious enclosure which can take various shapes depending on the gods associated with it.

Siren: from ancient Greek mythology (mermaids, mermen); by the Medieval period often shown as fish-legged humans with split legs terminating in twin fishtail-forms.

Sudan (Eastern): refers to the Central African savanna as well as the country south of Egypt (where Nubian culture once dominated).

Sudan (Western): refers to the West African savanna area between the forests and Sahara Desert.

Tribe: generally a pejorative term for African cultures and civilizations that emerged in the colonial era.

Zoomorphism: the attribution of animal characteristics to other forms, such as humans or buildings.

FURTHER READING

Blench, Roger, *Archaeology, Language, and the African Past* (Lanham, MD: AltaMira Press, 2006)

Blier, Suzanne Preston, *Royal Arts of Africa: The Majesty of Form* (London: Laurence King, 2012)

Blier, Suzanne Preston (author) and James Morris (photographer), *Butabu: Adobe Architecture of West Africa* (Princeton, NJ: Princeton University Press, 2003)

Cole, Herbert M., *Maternity: Mothers and Children in the Arts of Africa* (Brussels: Mercatorfonds, 2017)

Doxey, Denise M., Rita E. Freed and Lawrence M. Berman, *Arts of Ancient Nubia* (Boston: Museum of Fine Arts, 2018)

Ehret, Christopher, *The Civilizations of Africa: A History to 1800* (Charlottesville, VA: University of Virginia Press, 2016)

Enwezor, Okwui and Chinue Achebe (ed.), *The Short Century: Independence and Liberation Movements in Africa 1945–1994* (London: Prestel, 2001)

Falola, Toyin and Timothy Stapleton, *A History of Africa* (Oxford: Oxford University Press, 2021)

Fauvelle, François-Xavier, *The Golden Rhinoceros: Histories of the African Middle Ages* (Princeton, NJ: Princeton University Press, 2018)

Fraser, Douglas and Herbert S. Cole (ed.), *African Art and Leadership* (Madison, WI: University of Wisconsin Press, 2004)

Gates, Henry Louis Jr, *Africa's Great Civilizations*. Public Broadcasting System (Television Series), 2017

LaGamma, Alyssa, *Kongo: Power and Majesty* (New York: Metropolitan Museum of Art, 2015)

— *Sahel: Art and Empires on the Shores of the Sahara* (New York: Metropolitan Museum of Art, 2020)

McDonald, Kevin and François Richard (eds), *Ethnic Ambiguity and the African Past: Materiality, History and the Shaping of Cultural Identities* (London: Routledge, 2015)

Meier, Sandy Prita, *Swahili Port Cities: The Architecture of Elsewhere* (Bloomington, IN: Indiana University Press, 2016)

Ogundiran, Akinwumi and Toyin Falola (eds), *Archaeology of Atlantic Africa and the African Diaspora* (Bloomington, IN: Indiana University Press, 2010)

Okeke-Agulu, Chike and Okwui Enwezor, *Contemporary African Art Since 1980* (Bologna: Damiani, 2009)

Teeter, Emily (ed.), *Before the Pyramids: The Origins of Egyptian Civilization* (Chicago, IL: Oriental Institute of University of Chicago, 2011)

Thompson, Robert Farris, *Flash of the Spirit: African & Afro-American Art & Philosophy* (New York: Vintage, 1984)

Thornton, John, *Africa and Africans in the Making of the Atlantic World, 1400–1800* (Cambridge: Cambridge University Press 1998)

Visona, Monica Blackmun, Robin Poynor and Herbert M. Cole, *History of Art in Africa* (Hoboken, NJ: Prentice Hall, 2007)

PICTURE CREDITS

—

To my mentor, Douglas Fraser, who inspired a deep passion for African art's rich historical dimensions.

—

First published in the United Kingdom in 2023 by Thames & Hudson Ltd, 181A High Holborn, London WC1V 7QX

First published in the United States of America in 2023 by Thames & Hudson Inc., 500 Fifth Avenue, New York, New York 10110

The History of African Art © 2023 Thames & Hudson Ltd, London

Text © 2023 Suzanne Preston Blier
Design by April

British Library Cataloguing-in-Publication Data
A catalogue record for this book is available from the British Library.

Library of Congress Control Number 2023934838

ISBN 978-0-500-29625-7

Printed and bound in China by Toppan Leefung Printing Limited

MIX
Paper from responsible sources
FSC® C104723
www.fsc.org

Be the first to know about our new releases, exclusive content and author events by visiting
thamesandhudson.com
thamesandhudsonusa.com
thamesandhudson.com.au

Front cover: Yoruba Seated Figure, possibly from Ile-Ife, collected at Tada, Nigeria, late 13th/14th century. Copper, 53.7 x 34.3 x 36 cm (21¼ x 13⅝ x 14¼ in.). National Museum of Lagos. National Commission for Museums and Monuments, Nigeria. Photo akg-images/Andrea Jemolo

Title page: Zanele Muholi, *Bester V, Mayotte*, 2015 (detail from page 156). Silver gelatin print, image size: 50 x 41 cm (19¾ x 16¼ in.), paper size: 60 x 51 cm (23⅝ x 20⅛ in.). Edition of 8 + 2 © Zanele Muholi. Courtesy of Stevenson, Cape Town/Johannesburg/Amsterdam and Yancey Richardson, New York

Page 4: Baga wood carver, Baga D'mba mask headdress (also reproduced on page 27). Guinea, 19th–20th century. Wood and brass, 132 x 39 x 61.5 cm (52 x 15⅜ x 24¼ in.) Yale University Art Gallery, New Haven

Chapter openers: page 8 Mende wood carver, Sande Sowei mask, Sierra Leone, mid-20th century (detail from page 29); **page 32** Egyptian painter, Painted relief of Queen Iti, co-ruler from Punt Hatshepsut's mortuary temple, Deir el-Bahri, Egypt, c.1473–58 BCE (detail from page 45); **page 58** Marrakech architect, Kutubiyya Mosque minaret and exterior walls, Marrakech, Morocco, 1195 (detail from page 74); **page 85** Swahili wood carver, Door, Stone Town, Zanzibar, Tanzania, 19th century (detail from page 103); **page 106** Kota artist, Reliquary figure (*mbulu ngulu*), Gabon, 19th–20th century (detail from page 110); **page 128** Kongo artist, Kongo Nkisi-Nkonde figure, Democratic Republic of Congo, 19th–early 20th century (also reproduced on page 134); **page 146** El Anatsui, *Gravity and Grace*, 2010 (detail from page 153); **page 158** Muhammad Rumfa, Kano (Hausa) Palace, Dome interior, Nigeria, built 1470–99 (detail from page 164)

ACKNOWLEDGEMENTS

With gratitude to the staff and fellows at Harvard University's I Tatti Center for Italian Renaissance Studies in Florence, Italy, where the bulk of this book was written. Special thanks also to: Ana Lucia Araujo, Roger Blench, Sandro Capo Chichi, Gérard Chouin, Herbert Cole, Rita Freed, Cecile Fromont, Henry Louis Gates, Jr, Candice Goucher, Lisa Homann, Shamil Jeppie, Alisa LaGamma, Frederick Lamp, Kevin McDonald, Steven Nelson, Jennifer Peruski, Robin Poynor, John Thornton, Barbara Worley and Gary Van Wyk. As always, a special thanks to Rudy.